THE BRITISH ANTARCTIC EXPEDITION

SOUTH POLE

1910 · 1913

All photos © Scott Polar Research Institute,
University of Cambridge, except the following:
Pages 1 and 3: © National Maritime Museum, Greenwich, London.
All rights reserved, www.nmmimages.com.
Page 9: © The British Library Board, the Picture Library of the British Library.
Page 131: © Toby Strong/baobabfilms.co.uk.
Page 132: Courtesy of Sir Ranulph Fiennes.

© 2011 Assouline Publishing
601 West 26th Street, 18th Floor
New York, NY 10001, USA
www.assouline.com
ISBN: 9781614280101
Printed in China.

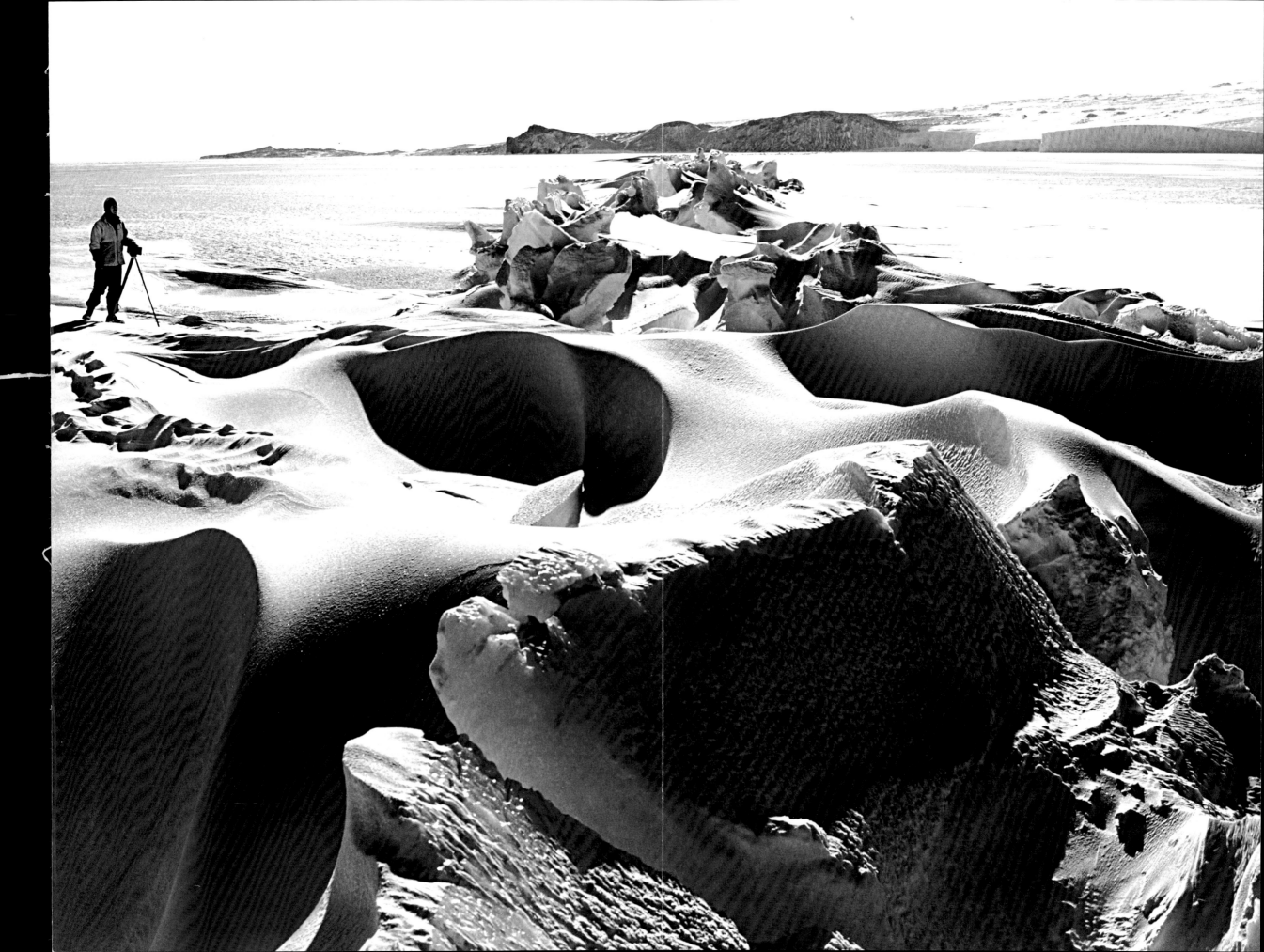

THE BRITISH ANTARCTIC EXPEDITION

Produced by
TANJA HALL ELLIS

Text by
CHRISTINE DELL'AMORE

Forewords by
HIS SERENE HIGHNESS PRINCE ALBERT OF MONACO

HER ROYAL HIGHNESS THE PRINCESS ROYAL,
PRINCESS ANNE OF GREAT BRITAIN

SOUTH POLE

1910 · 1913

ASSOULINE

Foreword by His Serene Highness
Prince Albert of Monaco

Palace of Monaco,
July 2011.

I always had a great interest for polar history. My great-great-grandfather, Prince Albert I, made four Arctic trips between 1898 and 1907. In 2006 I journeyed to the Geographic North Pole and in 2009 achieved a personal goal of skiing to the Geographic South Pole.

Upon reaching the South Pole and in the presence of a modern adventurer, Norwegian Børge Ousland, and I wish to thank him as well as Mike Horn, for guiding us there, my thoughts turned to the heroic figures one hundred years ago ; the legendary Norwegian explorer, Roald Amundsen, and the famed British officer Robert Falcon Scott. Their journeys and the fate that befell Captain Scott and his polar party captivated the world's attention like no other discovery.

Beyond the incredible feats of endurance, hardship and tragedy, and the prodigious scientific achievements from Scott's last attempt, the world was captivated in no small part due to Captain Scott's prowess as a diarist and the outstanding photographic skill of team member Herbert Ponting. The written and photographic legacy enabled people to connect with this journey as never before.

Surprisingly, Captain Scott's last expedition base in Antarctica still remains.

I was privileged during my visit to Antarctica to be able to visit his last base camp at Cape Evans on Ross Island. It is a most extraordinary place crammed with its original contents, including much of Ponting's photographic equipment. Considered the holy grail of Antarctic heritage by many, it is powerful, evocative, humbling, and precious. It provides a rare opportunity to feel an intimate connection to this heroic age of exploration, a moving moment for me.

The formidable challenge of conserving the historical hut in such a remote location rests with a New Zealand charity. The Antarctic Heritage Trust's efforts to save this site for current and future generations have been outstanding and its worthy mission has attracted support globally.

A century on from Amundsen's and Scott's attainment of the South Pole, I am delighted that this book profiling the incredible story and photography from Captain Scott's final expedition has been commissioned to benefit the Antarctic Heritage Trust's mission.

My hope is that the historic base left by Captain Scott on his final expedition one hundred years ago inspires the human spirit as we jointly face the challenges of protecting our environment.

Albert de Monaco

PREVIOUS PAGES: Scott next to a path of jagged snow and ice extending across a flat snowfield, October 8, 1911.
OPPOSITE: A map showing areas of Antarctica explored by 1911.

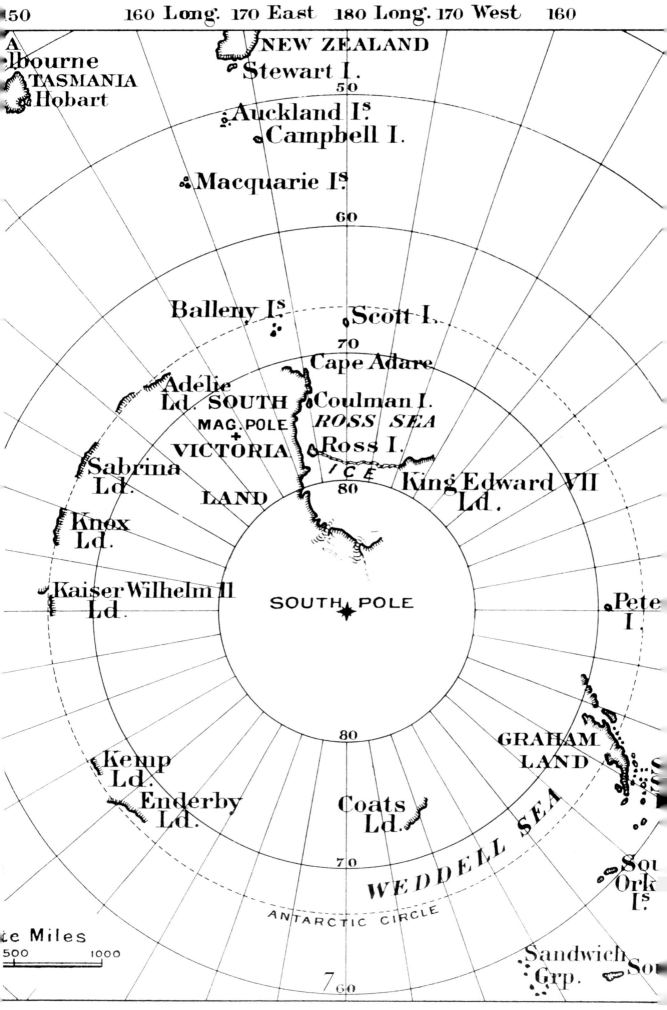

Foreword by Her Royal Highness The Princess Royal,
Princess Anne of Great Britain

BUCKINGHAM PALACE

Great explorers fascinate and inspire us all. Captain Robert Falcon Scott's last expedition to Antarctica made huge advances in humanity's understanding of the hostile and hitherto largely unknown continent. However it was the target of the South Pole which most caught the public imagination. Scott, with four companions, attained the Pole on 17 January 1912, but was bitterly disappointed to discover that the Norwegian Roald Amundsen had got there over a month earlier. These achievements were largely overshadowed by the tragic deaths of Scott and his team on the return journey.

Scott's expedition base, although simply made of wood, still survives, and contains thousands of items of supplies and equipment left by the expedition. I have been fortunate to visit it, and was intensely moved by its haunting and evocative atmosphere. Standing inside the building is a very humbling experience and I can testify that in a storm it still provides welcome shelter and refuge from the savage Antarctic climate.

This book, with its vivid account of Scott's expedition, and its many remarkable pictures taken by their camera artist, Ponting, keeps alive in today's world this epic story of exploration and discovery from a century ago.

I welcome that this book has been commissioned to commemorate the centenary of Scott's last expedition and that proceeds will support the Antarctic Heritage Trust's Ross Sea Heritage Restoration Project which I launched in Antarctica. In doing so it will directly help preserve Scott's Antarctic legacy.

May Scott's story long continue to fascinate and inspire present and future generations.

Anne

OPPOSITE: The last page of Robert F. Scott's diary, from March 29, 1912. *FOLLOWING PAGES:* Scott, Oates, and Evans standing in front of a Union Jack flag at the South Pole, with Bowers and Wilson sitting in front.

we shall stick it out
to the end but we
are getting weaker of
course and the end
cannot be far,
It seems. a pity but
I do not think I can
write more —
 R Scott
Last Entry —
For Gods sake look
after our people

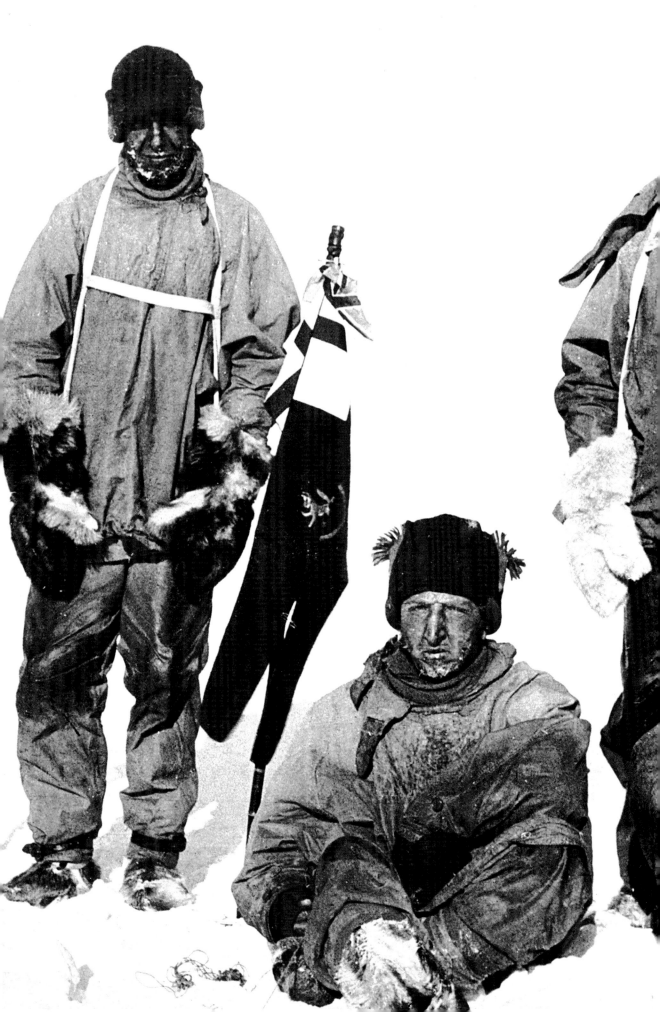

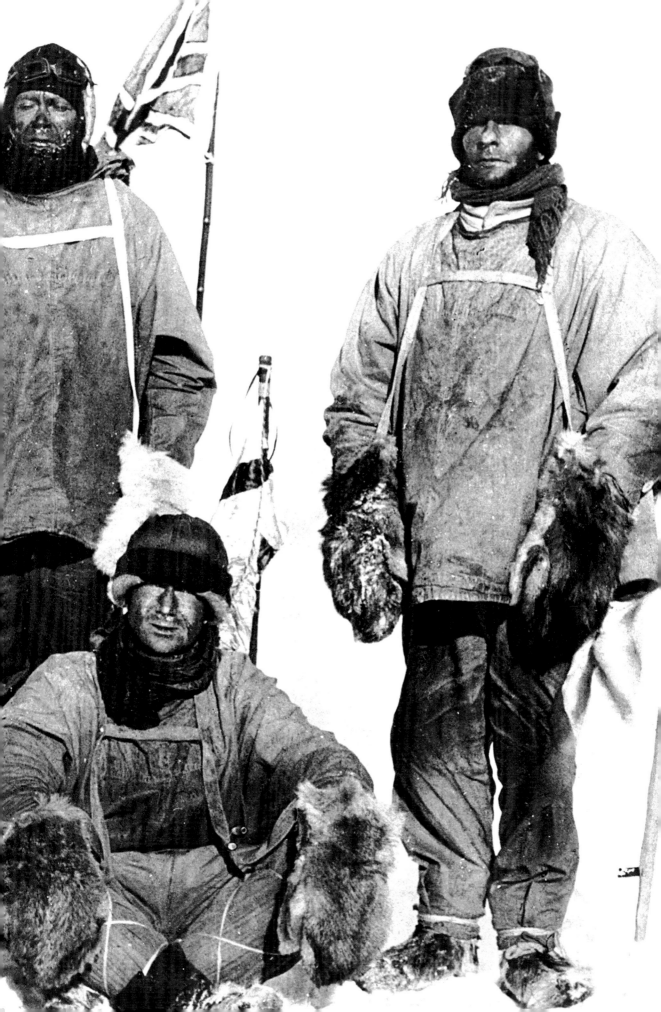

Introduction

Antarctica can humble even the hardiest of explorers. Predominantly a vast, snowy desert, Antarctica boasts a sunless winter with temperatures dipping into the -100s Fahrenheit. Summertime at the South Pole brings frigid gusts that can numb exposed skin in seconds, and the continent's combination of high altitude and the world's driest air poses a challenge to simple movement at any time of year.

Which is why it's all the more remarkable that one hundred years ago, a team of British explorers pulled sledges for hundreds of miles on a journey from the Ross Sea to the South Pole—then the most coveted spot on the continent.

For the final push, a party of five men—known as the polar party and led by Captain Robert Falcon Scott—arrived at the Pole on January 17, 1912, hoping to be the first to plant its flag at Antarctica's desolate heart. Yet they were too late: Seasoned Norwegian explorer Roald Amundsen and his team had already reached the Earth's southernmost point.

Tragically, on the freezing trek back to their hut on Ross Island, the polar party perished—three of them from starvation and exposure, in a tent just eleven miles from salvation.

The adventurers had died in the midst of the heroic age of polar exploration, a time when Antarctica was still largely uncharted and unstudied.

Scott, who had risen quickly through the naval ranks since joining at age thirteen, had already garnered fame during his successful *Discovery* expedition to Antarctica between 1901 and 1904. It was on this journey that several scientific firsts were accomplished—among them mapping new lands and collecting two years of valuable climate and atmospheric records. The trip also had set a record for the farthest trip south: Scott and his team sledged within 480 miles of the Pole.

Scott returned to England in 1904 to widespread accolades and a promotion to captain. He married the sculptor Kathleen Bruce in 1908, and their first and only child, Peter, was born not long after. Despite his agreeable circumstances, however, Scott felt restless and gladly sprung to action in 1909, upon hearing that his former *Discovery* lieutenant and now rival, Ernest Shackleton, had trekked within ninety-seven nautical miles of the Pole.

Later that year, Scott launched his second Antarctic expedition. The British government, schoolchildren, and companies all pitched in to raise the needed 40,000 British pounds, roughly 2.2 million pounds today. Unable to use the custom-built *Discovery*, Scott selected the old whaler *Terra Nova*, which had traveled to the Antarctic once before.

Though the Pole was the main trophy, the three-year *Terra Nova* expedition also focused on furthering scientific research. Scott recruited the most sizable Antarctic scientific team to date, including the *Discovery* zoologist Edward Wilson, a longtime friend of Scott's who also had accompanied the explorer on his previous Antarctic expedition.

The group worked doggedly on scientific experiments on Cape Evans, Ross Island. The base where they endeavored continues to stand today due to conservation efforts by the Antarctic Heritage Trust.

The photographer and artist Herbert Ponting also joined the team, and his pictures of polar scenes around Cape Evans would later sear the tragedy into public consciousness.

Eight thousand men applied for the adventure, including Lieutenant Henry Bowers of the Royal Indian Marine and former *Discovery* seaman Petty Officer Edgar Evans. Still others purchased their places on the trip, such as cavalry officer Lawrence Oates and a wealthy young man named Apsley Cherry-Garrard, who later wrote a memoir about the expedition, *The Worst Journey in the World*. Wilson, Scott, Bowers, Evans, and Oates would make up the doomed polar party.

As he lay dying, Scott penned his "Message to the Public," the clear-headed and poignant last words that would elevate the expedition to its legendary status.

"Had we lived," he wrote, "I should have had a tale to tell of the hardihood, endurance, and courage of my companions which would have stirred the heart of every Englishman."

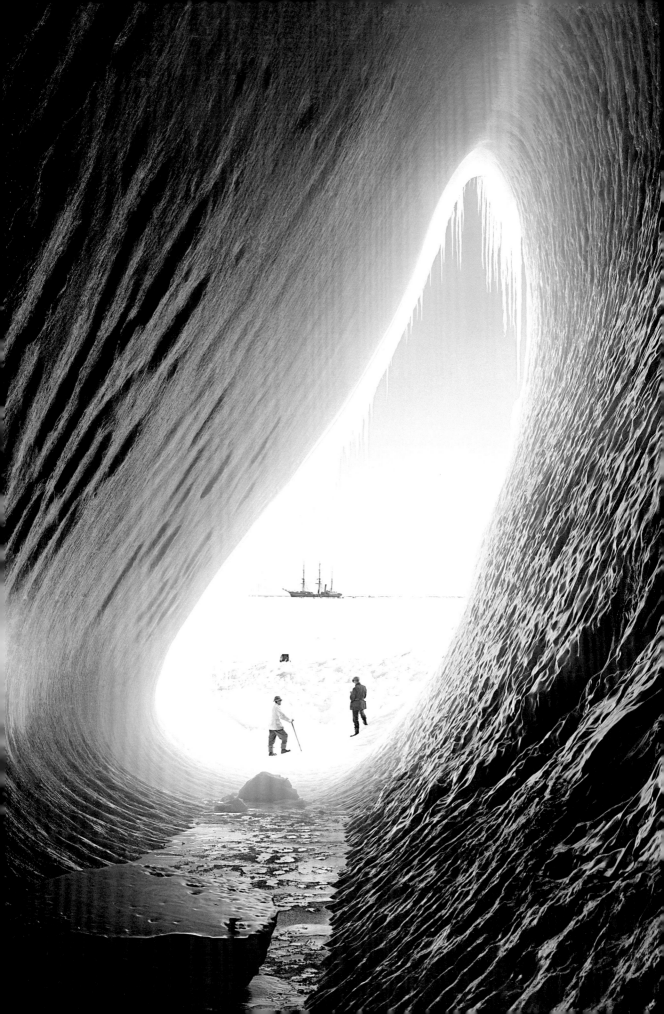

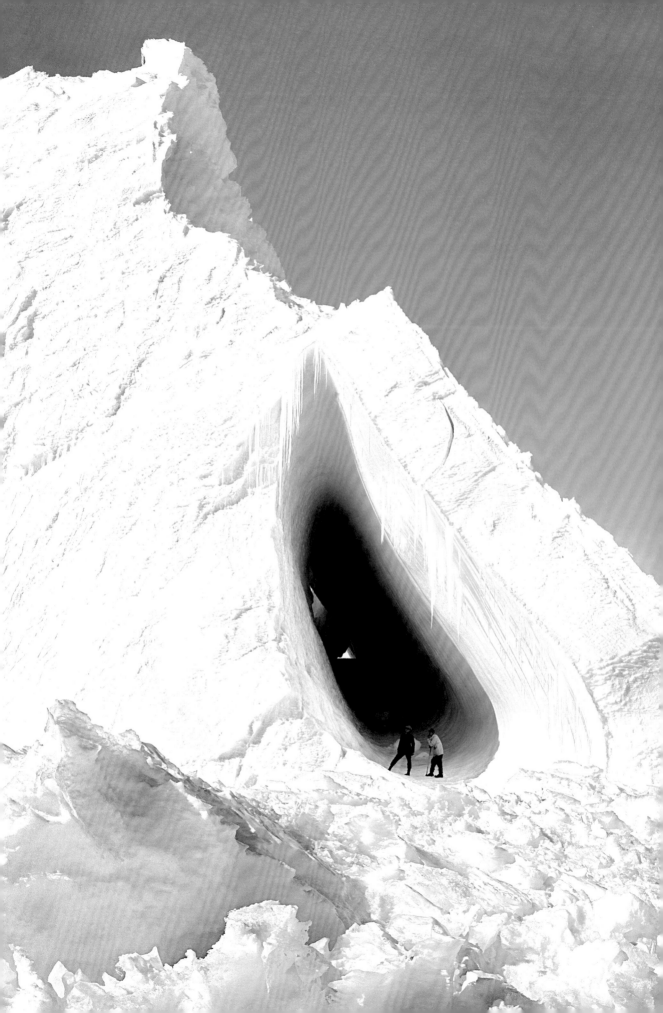

Journey to Antarctica

When the *Terra Nova* departed Cardiff, Wales, on June 15, 1910, she set into motion a series of extraordinary events that would begin at sea. In the five months spent sailing to Antarctica, the expedition was endangered twice, once by a vicious storm and again while navigating nearly impenetrable sheets of ice. Even so, Captain Robert Falcon Scott's sixty-five-person team of officers, seamen, and scientists responded with indomitable gusto. Regardless of rank, everyone pitched in when work called, from shortening sail to pumping coal.

The scientific team, led by the zoologist Edward Wilson, went to work immediately. While at sea the scientists took magnetic and meteorological observations, measured ocean depths and sediment, and collected or observed a myriad of life forms, from tiny plankton to the largest mammal on Earth, the blue whale. *Terra Nova*'s slow pace attracted a score of curious wildlife, with dolphins darting at the bow and many a seabird wheeling overhead. Everyone aboard took part in cataloging animals, and the ship constantly resounded with cries of "Whale!" or "Dolphin!" Songs also accompanied the flurry of science and labor, though, as assistant zoologist Apsley Cherry-Garrard noted in his book *The Worst Journey in the World*, "there was hardly anybody in [the expedition] who could sing." As *Terra Nova* headed south, making a few ports of call in the South Atlantic, a heady atmosphere of anticipation grew among the men. But in October, Scott got a rattling telegram: "Beg leave to inform you *Fram* proceeding Antarctic. Amundsen." The experienced Norwegian explorer, who had just been beaten to the North Pole, had now set his sights on the south. The race was on.

In late October *Terra Nova* made its last landing in New Zealand, where Lieutenant Henry Bowers masterfully crammed every inch of the wooden whaler with supplies. Among the cargo were several prefabricated huts, beds with spring mattresses, all manner of scientific and photographic gear, 3 motor sledges, 162 mutton carcasses, 19 ponies, 33 dogs, 2.5 tons of petrol, and more than 450 tons of coal. (While more modern ships of the time—such as Amundsen's *Fram*—had switched to petrol, *Terra Nova* still ran on coal.) "To say we were heavy laden," Cherry-Garrard wrote, "is a very moderate statement of facts."

Terra Nova set out from New Zealand on November 26, almost the beginning of the Southern Hemisphere's summer. As she plowed into the seas off Antarctica in early December, a ferocious storm barreled in, unleashing thirty-five-foot waves that began to sink the ship. Armed with only buckets, a determined crew worked around the clock to bail out the drowning *Terra Nova*. When the gale died down, the expedition had lost two ponies, a dog, ten tons of coal, and sixty-five gallons of petrol—but none of its high spirits.

Yet another trial soon followed: a nearly monthlong battle on a four-hundred-mile stretch of pack ice, a winter sea ice that forms over Antarctica's Ross Sea and is later blown northward. Much to Scott's dismay, the ship consistently got stuck in the ice—once for five days—until the ice floes broke apart in the warming temperatures. Scott grew fond of the *Terra Nova* as she "bumped the floes with mighty shocks, crushing and grinding a way through some...she seemed like a living thing fighting a great fight," he wrote in a letter home.

The delays had their benefits, though—such as giving the ship-weary men a chance to exercise. Sub-lieutenant Tryggve Gran, a Norwegian ski expert, gave lessons on the floes, honing skills for the sledging trips to come. The beauty of the landscape dazzled, from the twenty-five-foot-high ice pinnacles to mornings that suffused the sky with mauves, greens, and brilliant blues. The pack's calm set a peaceful backdrop for Christmas Day 1910, with the officers lustily singing hymns over a dinner of Adélie penguin and champagne.

They reached Ross Island, a volcanic island off the Ross Sea, on New Year's Eve. But as the ship approached Cape Crozier—the expedition's intended hut site on the eastern edge of Ross Island—Scott soon realized that rough waves near the shore would make landing and unloading difficult. And so Scott abandoned that plan and decamped at a peninsula previously called the Skuary because skuas, large sea birds related to gulls, nested in the area. He renamed it Cape Evans, after Lieutenant Teddy Evans, the ship's second-in-command. The cape sits on McMurdo Sound, an inlet of the Ross Sea that also abuts the Great Ice Barrier—a France-size piece of freshwater ice now called the Ross Ice Shelf. Setting up camp here gave them closer access to the Barrier, which would make up the first leg of the trip to the South Pole the following summer.

"*When* Terra Nova *departed Cardiff, Wales, on June 15, 1910, she set into motion a series of extraordinary events that would begin at sea.*"

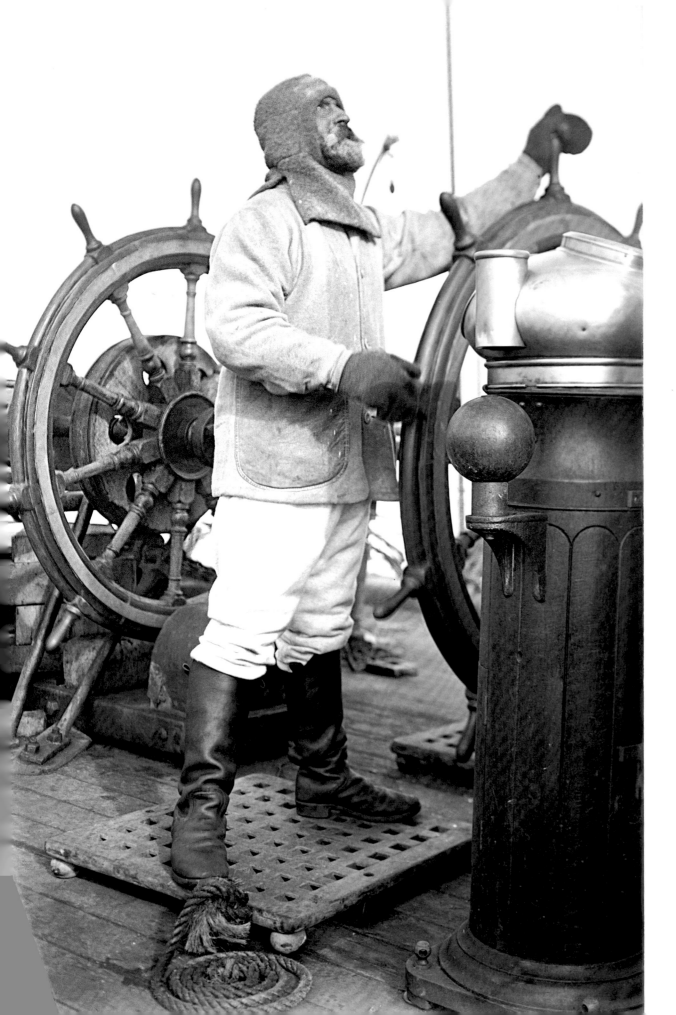

Laying the Depots

A chaotic scene often unfolded as the team unloaded the dogs, ponies, and motor sledges from the ship onto the beach at Cape Evans. Curious groups of Adélie penguins continued to approach the chained dogs, only to get snapped up and eaten. One of the three motorized sledges—which Scott brought along as an experiment in polar traveling—fell through the unstable ice of the Sound. A pod of orcas appeared, and with surprising cunning rose under and broke a piece of ice bearing the expedition's photographer, Herbert Ponting, and several dogs. Ponting and the dogs narrowly escaped.

Over the next week a crew assembled the premade hut close to shore, taking special care to ventilate and insulate the building. Connected to the hut was a stable housing the ponies, which were brought to haul sledges. The camp sat in the shadow of the smoking 12,447-foot Mount Erebus, Earth's southernmost active volcano. Over the icy Sound lay the Western Mountains, "a vision of mountain scenery that," in Scott's words, "can have few rivals."

In January 1911, a group of twelve men, accompanied by eight ponies and two dog teams pulling sledges, set out from Cape Evans to store supplies along part of the route for the following summer's South Pole journey. The course had been tested before by Shackleton's *Nimrod* expedition (1907–1909), and Scott had planned it out in three stages: 425 miles on the Barrier, 125 miles over a giant glacier called the Beardmore, and the last 350 miles across the high-altitude plateau in the continent's interior. The round-trip journey would cover an astounding 1,800 miles.

As a base, the depot teams used Hut Point, Scott's hut from the *Discovery* expedition, situated approximately fifteen miles across McMurdo Sound.

While some of the scientists stayed at the Cape Evans hut to work on their experiments, *Terra Nova* dropped off the geologist T. Griffith Taylor's western geological party to explore the Western Mountains for the first time. *Terra Nova* then planned to take Lieutenant Victor Campbell and his eastern party along the Barrier's edge to survey King Edward VII Land.

Meanwhile, the depot-laying teams were struggling. Frequent blizzards and giant crevasses—deep cracks in the ice—slowed work, and even the sturdy Siberian

ponies were having trouble, often sinking to their knees in the snow. The animals rapidly declined in health, and of the eight, only two would return. The dog teams were faster but no more fortunate. At one point a dog team fell into a crevasse, the sledge and lead dog still on the ice at either side of the crevasse, while the middle dogs dangled into the void before being rescued.

The most anxious moment came when a pony team returning to Hut Point was almost lost at sea on McMurdo Sound's unreliable ice. When the Sound froze for the winter, a person could walk across it. But Scott's men were often overestimating its stability, as in the case of Bowers' pony team, which camped one night on the ice. When Bowers woke up, he found himself in the middle of floating ice. "We had been in a few tight places," he wrote, "but this was about the limit." Despite lurking orcas and the disintegrating ice, his team escaped, although they were forced to kill two of the ponies that couldn't make it off the floes.

Scott and his depot teams regrouped in March at Hut Point, having laid several caches of food and fuel that would be vital for the polar journey. Even so, the men were somewhat chastened by their months on the ice. As Bowers admitted, "We shall start for the Pole with less of that foolish spirit of blatant boast and ridiculous blind self-assurance, that characterized some of us on leaving Cardiff." Already disappointed by the deaths of the best ponies, and feeling less confident in the dogs, Scott received more upsetting news at Hut Point. Campbell's group, deterred by pack ice, had changed course to the Bay of Whales at the eastern edge of the Barrier—and was shocked to find Amundsen's ship, the *Fram*. Even so, the exchange was cordial: A few members of Campbell's party had breakfast with the other team, and Amundsen and some of his men lunched on the *Terra Nova*. In general, Campbell's men were impressed by the Norwegians' formidable natures—"evidently inured to hardship," observed the geologist Raymond Priestley.

Amundsen had made the risky decision to tackle the Pole from the Bay of Whales—a new route that put his team sixty miles closer to the Pole, as well as allowed them to start earlier in the spring. Add to that more than a hundred dogs and experience on snow, and Amundsen's expedition posed a "serious menace," Scott acknowledged.

Terra Nova went back to Cape Evans to report the *Fram* encounter, then continued north to Cape Adare to drop off Campbell's renamed northern party.

Hut Life and Winter Journey

After the sea ice froze on the Sound, the depot-laying teams trekked back from Hut Point to the hut at Cape Evans, well broken in and abuzz with science. At fifty feet long by twenty-five feet wide, it was the largest building in Antarctica at the time and felt as "palatial as is the Ritz," Cherry-Garrard remarked. As was custom, Scott had divided the hut into the wardroom—an area restricted to the sixteen officers and scientists—and the mess deck, for the nine remaining workers, including the seamen. (Several people, called the Ship's Party, stayed aboard the *Terra Nova*, which would return to New Zealand during the winters.) The bunk-lined wardroom had a large table at its center, as well as Scott's "den"—with his bed, table, and bookshelves. The wardroom also contained workbenches for the scientists and Ponting's darkroom, which doubled as a bedroom for the photographer. The mess deck had the other men's bunks and two more tables, one for eating and one for the cook, Thomas Clissold, to prepare food. Ponting took staggering photographs of the icebergs and other ice formations around Cape Evans.

As winter wore on, life slid into a predictable cadence. The scientists worked furiously, tending to scientific experiments, such as meteorological observations on the sixty-six-foot-high Wind Vane Hill located behind the hut. The sun sank below the horizon in April, causing outdoor tasks such as skiing and exercising the ponies to be done by moonlight. Yet all of this work rotated around regular mealtimes. A wardroom breakfast might consist of porridge and fried seal liver; lunch, limited bread, butter, and jam; and dinner, soup, seal or penguin, tinned vegetables, and pudding, in addition to mutton two times a week. (Many on the expedition also drank lime juice to ward off scurvy.) On June 6, the wardroom celebrated Scott's forty-third birthday with an elaborate dinner, topped off by a giant cake decorated with chocolate, fruit, flags, and photographs of the explorer. After most dinners, someone would put on the gramophone—music being a soothing reminder of civilization—and three times a week, the wardroom residents took turns presenting evening lectures. The talks ranged from Bowers' "Evolution of Polar Clothing" to Charles Wright's discourse on the origin of matter (which "left many of us somewhat befogged," noted Cherry-Garrard) to Ponting's popular travel slide shows, featuring

lush scenes of India and Japan that transported the men, albeit temporarily, out of the polar darkness. By 10 p.m. most were already tucked into bed, with a candle, a book, and often a piece of chocolate.

In late June, Cherry-Garrard, Bowers, and Wilson departed on a journey to collect emperor penguin eggs at Cape Crozier, the only known rookery for the four-foot-tall birds. No one had ever attempted a winter journey, but the potential scientific payoff made it worth the risk. At the time, many scientists believed the now-disproved recapitulation theory, which held that as an embryo develops, it passes through all the physical stages of its past ancestors. Thinking erroneously that emperor penguins were primitive species, Wilson suspected that studying the birds' embryos might reveal some mysterious ancestors of birds, such as reptiles.

And so, hauling two sledges with six weeks' worth of provisions, the team started on what Cherry-Garrard dubbed the "weirdest bird's-nesting expedition that has ever been or ever will be." On the nineteen days to the cape, the mercury dipped into the -70s, and near-total blackness often disoriented the men. The unforgiving cold impeded them at every step. During their exhausting marches, sweat froze their clothes hard, and at night the moisture of their breath would turn sleeping bags into ice blocks. Nighttime shivering fits would seize Cherry-Garrard with such intensity that he thought his back would break. The days walking to the cape were "the worst I suppose in their dark severity that men have ever come through alive," according to Cherry-Garrard.

Finally reaching Cape Crozier, the trio built a temporary home—a rock-walled igloo with a canvas roof and a wooden board that acted as a door. During their stay they managed to collect five eggs from the penguin rookery, which they hoped to pickle in alcohol for future scientific analysis. However, one night a tremendous blizzard blew away the tent, which had been secured close to the igloo. Traveling seventy miles back to Cape Evans without a tent would mean likely death. But in a stroke of luck, the men found the tent nearby and made it home, an effort Scott recorded in his journal as heroic.

What of the eggs? Three made it back to a lab, and scientist James Cossar Ewart of the University of Edinburgh found in them a crucial clue for how bird feathers originated. And so, Cossar Ewart wrote in a research summary, "The worst journey in the world in the interest of science was not made in vain."

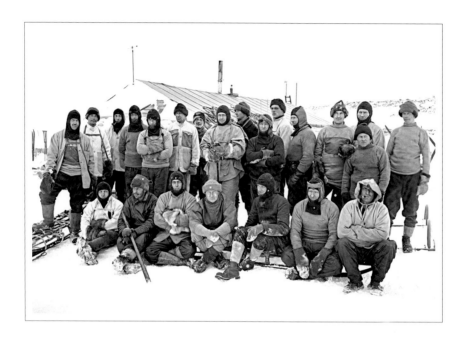

The attitude of the men is equally worthy of admiration. In the forecastle as in the wardroom

there is a rush to be first when work is
to be done, and the same desire to sacrifice selfish
consideration to the success of the expedition.
It is very good to be able to write in such

high praise of one's companions, and I feel that

the possession of such support ought to ensure success.

Robert F. Scott

The shore party, October 1911.
OPPOSITE: Four expedition members at the doorway of Ernest Shackleton's hut at Cape Royds.
A pole with three pennants attached is across the doorway.

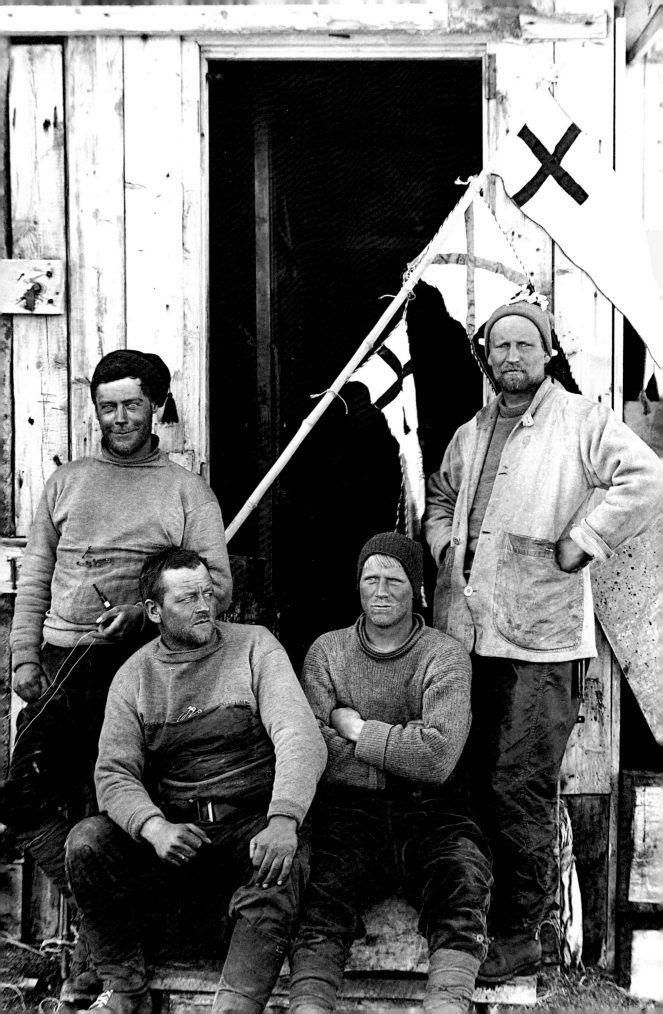

South Pole Journey Begins

Spring arrived, and sledging started anew. The men were able to test a telephone line laid in September, which ran across the sea ice between the huts at Cape Evans and Hut Point, the departure point for the southern journey. In October, the sixteen men who would participate were ready. Between them were five tents, ten ponies, twenty-three dogs, thirteen sledges, and several pairs of skis, which they would use primarily in the latter half of the trip. Bowers tirelessly had worked out the weights of dogs, motors, ponies, and food, calculating the amount of food the men would carry for themselves and the animals in between depots. He had also studied the optimal types of food and clothing to bring, such as a sledger outfit of warm reindeer-fur boots called finneskos, giant fur mitts, and goggles to prevent snow blindness. As navigation tools they had a variety of instruments, including compasses and theodolites—telescopes that record the position of the sun and help determine a precise location—as well as sledge meters for measuring geographical distances. And, of course, they had records of Shackleton's prior route. Scott was cautiously optimistic, stating: "I feel that our chances ought to be good."

According to the original plan, twelve of the sixteen men would turn back at different points in the journey, leaving four to complete the final push. Scott, however, decided at the eleventh hour to take five men to the Pole.

The first group, the motor party, took off on motor sledges on October 24. But by November 1, the four men had no choice but to abandon the machines, their engines unable to function in the cold. Though these motorized sledges would not usher in the new, hoped-for era of polar transport, they achieved small success in traveling fifty miles across the ice. The team that had been driving the motors continued by "man-hauling" its sledges.

On October 31 the pony party—divided into three groups based on speed—set off, followed by two dog teams on November 1. Ponting appeared with a dog sledge and his cinematograph long enough to catch some of the ponies in action. These teams marched at night, which was easier on the animals. The men left well-marked cairns by which they could retrace their route. Yet despite their best efforts at planning, a warm blizzard hit on November 13. The ponies struggled in the fresh

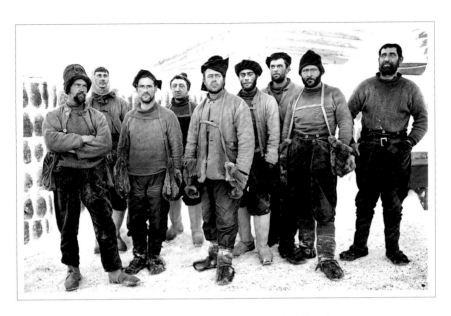

Captain Scott and expedition members at Cape Evans hut.

snow, and although they had been exercised faithfully all winter, the health of several animals quickly deteriorated. Cavalry Officer Lawrence Oates—who did not choose the ponies—frequently called them "the most unsuitable scrap heap crowd of unfit creatures that could possibly be got together."

After the teams arrived at One Ton Depot, about a third of the way to the edge of the Beardmore Glacier, Scott decided not to take the ponies on the glacier. The giant crevasses there were sizable enough to swallow the *Terra Nova*, and the animals could easily be lost. Instead he chose to kill the ponies and eat and store their meat at various points before they reached the foot of the glacier—certainly a difficult decision for Scott, whose sympathy for animals is expressed multiple times in his diaries.

Sledging on the Barrier was dismal work, especially "when sky and surface merge into one pall of dead whiteness," commented Scott. But when the sun shone, the sledgers' moods lifted. Cherry-Garrard wrote about the colors and shapes of the snow; the whisper of the sledge; the hiss of the primus, or portable stove; the smell of the nightly stew; and the soft folds of his reindeer sleeping bag. "How jolly they can all be, and generally were." He also described Scott's tent as comfortable, with a "homelike air" around dinnertime. The sledgers often would eat "hoosh"—a stew made of high-calorie English biscuits and pemmican (a mixture of dried meat and fat)—and drink water, tea, cocoa, or a combination of the last two, called "teaco."

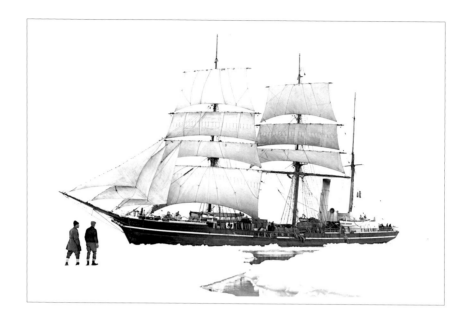

If the weather holds, we shall all get off to-morrow. So here end the entries in this diary with the first chapter of our History. The future is in the lap of the gods; I can think of nothing left undone to deserve success.

Two members of the expedition stand on ice, while *Terra Nova*, under sail, goes through pack ice. *OPPOSITE*: Ice formations at the base of a cliff. *FOLLOWING PAGES*: An expedition member stands on top of an iceberg, with Mount Erebus in the background. *PAGE 39*: A map showing Scott's and Amundsen's routes to the South Pole.

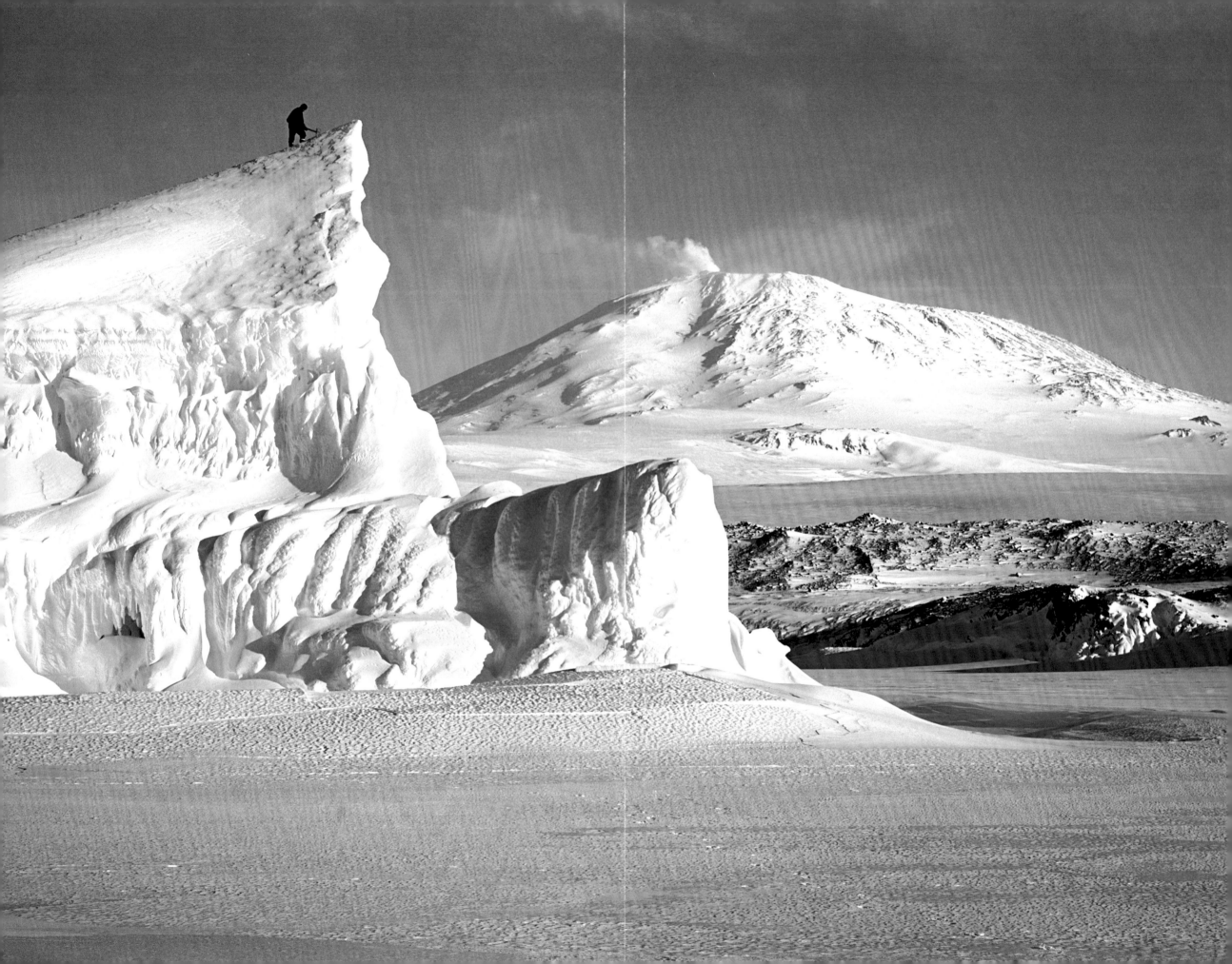

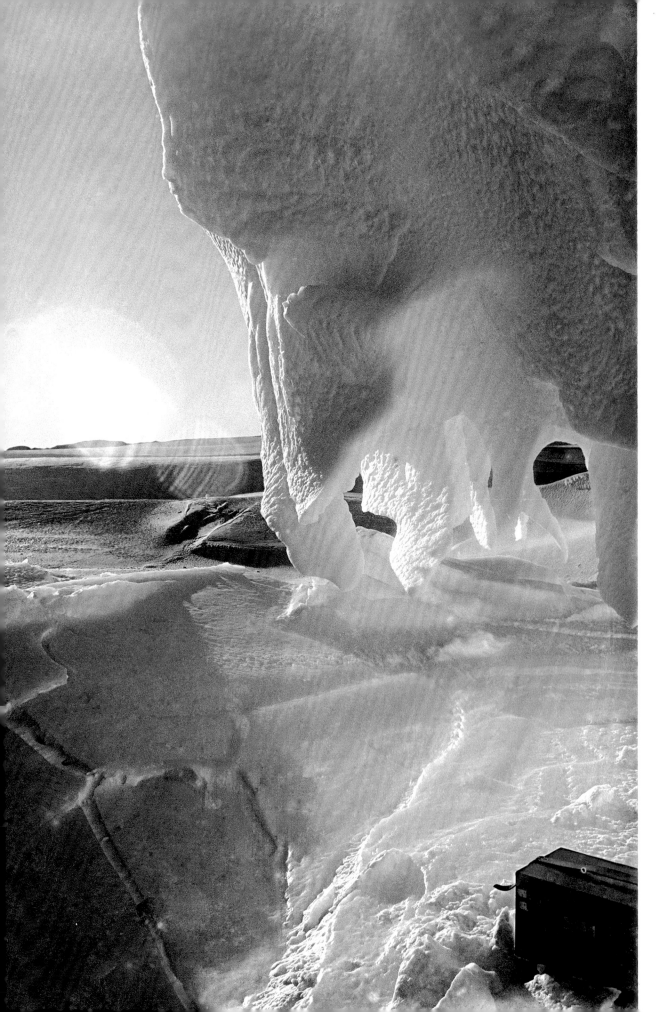

The Beardmore Glacier and the Pole

In early December the teams had reached the gap known as the "Gateway"—the access to the Beardmore Glacier. Cherry-Garrard described the sight as a "great white line of jagged edges," the result of the giant glacier grinding against the relatively stable ice of the Barrier.

But before they could move onto the glacier, a warm blizzard, unusual for summer, blew in. Warm temperatures (those above 30°F) melted the snow quickly, turning the sleeping bags into sponges and leaving the ponies shivering. Cherry-Garrard observed that such indeterminate delays bothered Scott more than disasters, which he generally faced with grit and optimism.

Eventually they crossed onto the glacier and entered into the second stage of the journey. With the last pony killed and stored, the expedition broke into three teams of four men each on skis. (Two man-haulers from the motor party had turned for home in late November, and the two dog drivers and their teams returned in mid-December.) The summer sun beat down on the travelers, burning faces and hands, cracking lips, and making everyone thirsty. "Tea at lunch," Cherry-Garrard wrote, was "a positive godsend."

As the men gradually gained altitude, they witnessed various polar peculiarities, including more sastrugi, wind-whipped patterns of snow that can resemble the surface of a stormy ocean. These features helped the men tell which direction the wind was blowing—and thus where to pitch their tents to avoid the worst gales. They maneuvered mazes of crevasses and ice walls, sometimes hiking up a wall and cruising down the other side. Sharp ice formations occasionally capsized the sledges. Overall, though, Scott selected the routes well, avoiding many of the dangers that Shackleton had faced.

Near the glacier's summit in late December, the first returning party of four men, including Cherry-Garrard, turned back, leaving a group of eight to continue into the third stage—the plateau. The remaining men had a "strange and strenuous" Christmas, Bowers reported. William Lashly fell clean through a crevasse, hanging from his harness into the abyss. "It was not of course a very nice sensation, especially on Christmas Day, and being my birthday as well," wrote Lashly, who was rescued.

Christmas dinner that night included special treats they had dragged south: chocolate éclairs, crystallized ginger, and four caramels per person.

As 1912 dawned, the team had reached an elevation of 9,392 feet, and the Pole lay only 180 miles away. On January 3, Scott abruptly resolved to take five men for the final push, despite the entire operation being painstakingly built around a four-person unit—from the food rations to the tents to the eating utensils.

The decision was costly: Having a fifth man would end up setting back the journey, weighing down the sledge, slowing travel (there were only four pairs of skis) and extending cooking time. Scott, as Cherry-Garrard noted, "had nothing to gain but everything to lose" from bringing an extra man.

Scott chose his most trusted and reliable members: Oates, Bowers, Wilson, and Petty Officer Evans—the latter considered very strong. Their average age was thirty-six, perhaps a bit older than ideal, but three out of five boasted previous experience in polar travel.

The second party, on its return home, had been given a note from Scott that read, "I think it's going to be all right. We have a fine party going forward and arrangements are all going well." That was true. The team was moving faster than had Shackleton's expedition and only needed to average seven miles a day to maintain its daily food rations for the last 148 miles to the Pole.

The five men set out pulling a heavily loaded sledge, with Bowers on foot, and before long they began to tire. Showers of ice crystals coated the snow, resulting in a sandy surface that bogged the men down. On January 16, after some of the hardest days yet experienced in the expedition, Scott came upon the scene he had long been dreading: a black flag, left by the Norwegians after they reached the South Pole—still some miles away—a month before. "It is a terrible disappointment, and I am very sorry for my loyal companions," Scott recorded.

On January 17 the men reached the Pole, and Scott found the harsh desert there, with its intense cold and fierce winds, an "awful place." The men camped just one night before resuming their march. A little while later, the party encountered a tent, in which Amundsen had left Scott a letter to pass on to King Haakon of Norway in the event of the Norwegian team's death. Nearby the crew built a cairn, flew the Union Jack, and took photographs of themselves. Then they set out for home. "All the day dreams must go; it will be a wearisome return," Scott admitted.

PART 6

Fateful Return

Indeed, as the team headed back from the Pole, following its old tracks and cairns, the cold tightened its grip. Temperatures averaged -20°F, and several men's cheeks, noses, and toes turned yellow with frostbite. Evans, who had previously injured his hand, had the worst case of frostbite. Unrelenting blizzards and the sandy, crystal-laden snow hindered their progress. "All the joy had gone from their sledging," Cherry-Garrard wrote.

By February 7 they had reached the top of the Beardmore Glacier, where the party anticipated warmer weather. Wilson, who hadn't even noted the Norwegians' coup in his journal, was still pursuing his science. He spent half a day collecting unprecedented rock samples—including pink limestone—from Mount Darwin, specimens he would keep with him to the very end.

Once on the glacier, the group took a wrong turn and hit a jumble of ice ridges dotted with huge chasms. Even the optimistic Scott admitted it to be the "worst ice mess I have ever been in." Though they got out of it eventually, on February 17 Evans collapsed. Wilson suggested he suffered a head injury during a fall. Already weak and frostbitten, Evans slipped into a coma and died. (Scott does not record what happened to his body.)

The team had no choice but to trudge on to the next depot, the only lifeline. After reaching it, the situation seemed to improve a bit. They had just gotten a week's worth of food, and there were three smaller depots in the 260 miles before the larger One Ton Depot. But then an even more bitter cold descended—"unexpected, unforetold, and fatal," as Cherry-Garrard put it. The lack of wind formed a cold layer near the ground, and temperatures dropped into the -30s by day and the -40s by night. The surface remained covered with ice crystals, and despite the unbearable cold they maintained for a short while a distance of at least eleven miles a day.

In early March, Scott voiced the first doubt about their survival. A succession of blizzards had only worsened the cold, and their gear became steadily more icy and difficult to manage. One of the depots was short on fuel, which had likely vaporized. Oates' feet were ravaged by frostbite. On March 4, Scott wrote, "we are in a very tight place indeed, but none of us despondent yet." The four men kept up a semblance of

normalcy, talking about faraway places in the tent at night. But Oates, described by Scott as "wonderfully plucky," grew more silent, likely realizing his fate. On March 11, after breakfast, Oates asked Scott for advice. Scott told him simply to keep marching as long as he could. On March 16 or 17, Oates awoke in such bad shape that he insisted the others leave him in his sleeping bag. Again, Scott convinced him to keep going.

That night Oates hoped he would die in his sleep. Scott recorded that his last conversations were about his mother and how proud his regiment would be that he had boldly met death. Finding himself still alive the next morning, Oates stood up and famously said, "I am just going outside and may be some time." He then walked to his death in a howling blizzard—apparently sacrificing himself for the survival of the others. "We knew it was the act of a brave man and an English gentleman," remarked Scott. "We all hope to meet the end with a similar spirit, and assuredly the end is not far."

The remaining three marched on in the stubborn cold, and on March 18 they pitched their last tent eleven miles from One Ton Depot, a distance that would have seemed negligible just a few weeks before. They had only two days of food and barely a day's worth of fuel. As a last resort Wilson and Bowers planned to trek to the depot to bring back food, but a severe blizzard roared for four days, preventing them from leaving. Too weak to move, the men decided to die naturally, instead of taking opium tablets that Wilson had carried in case of such a disaster.

As death closed in, Scott wrote a series of letters to the families of his comrades, his widow, and his friends, as well as his moving "Message to the Public." In the latter he expressed his surprise at the ruthless March cold. "No one in the world would have expected the temperatures and surfaces which we encountered at this time of year," he wrote, adding that "our wreck is certainly due to this sudden advent of severe weather."

"We took risks, we knew we took them; things have come out against us, and therefore we have no cause for complaint, but bow to the will of Providence, determined still to do our best to the last."

He noted that he did not regret the journey, "which has shown that Englishmen can endure hardships, help one another, and meet death with as great a fortitude as ever in the past."

On March 29, Scott scribbled his final words—"For God's sake look after our people."

Foreboding

Meanwhile, those back on Ross Island had no reason to think the party was in peril. In fact, its progress at last contact, in early January, suggested Scott and his team would return to Hut Point before predicted in late March.

Unaware of the Norwegians' success, the British expedition also was anxious to relay the Pole achievement as fast as possible to the wider world. So in late February, two small dog teams driven by Cherry-Garrard and the dog driver Demetri Gerof set out for One Ton Depot, carrying extra food for the polar party in case it was needed.

In the absence of Scott and Lieutenant Evans, who had gotten scurvy on his return from the polar journey and returned to New Zealand, Edward Atkinson had become *Terra Nova*'s senior officer. Atkinson instructed Cherry-Garrard to "judge what to do" if the polar party was not at One Ton Depot as suspected, while keeping in mind Scott's previous orders that the dogs were "not to be risked." When the dog teams arrived at the depot March 3, there was no sign of Scott and his men. Cherry-Garrard and Gerof waited until March 10 before turning back, oblivious that the four men were fighting for their lives just miles away. Going any farther south would have required killing dogs for meat, against Scott's orders. Even so, Cherry-Garrard's decision not to continue south weighed on him for the rest of his days.

A few uneasy weeks passed. Atkinson started out on another journey to find the polar party with Petty Officer Patrick Keohane. Just three days later, on March 30—the day after Scott was last known to be alive—Atkinson called off the search, now "morally certain that the party had perished." As winter drew on, the men realized the polar party's fate was sealed.

At the same time, on Evans Cove, in Victoria Land north of Cape Evans, Campbell's northern party was huddled in an underground igloo, surviving on seal and penguin. *Terra Nova* had been due to pick them up months before, but thick ice repeatedly thwarted her from getting close. On April 17, a late-season sledge party went looking for Campbell's party, thinking it would intercept the team on its way back. After a few fruitless days of searching, the team came back home, laying depots along the way for the stricken party. In April *Terra Nova* returned to Cape Evans, taking with her nine men—including Ponting—and leaving thirteen to brave it out for a second, decidedly lonelier, winter.

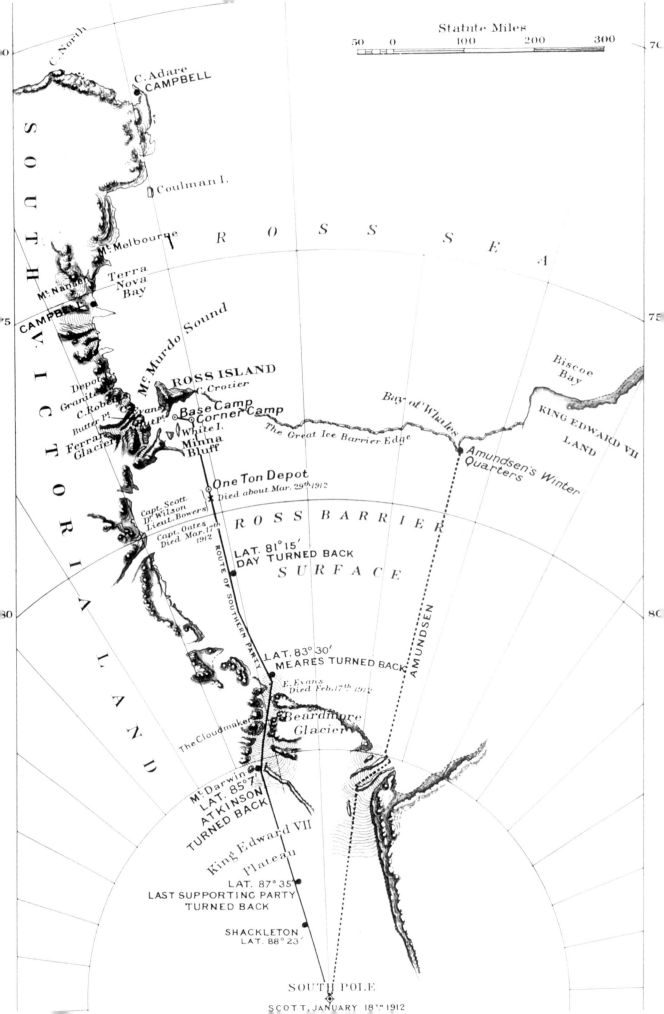

PART 8

Search Journey

With the arrival of spring in late October, two search parties—a mule team and a dog team—left Hut Point to search for Scott's party. On November 12, they found the tent and bodies. "To say it has been a ghastly day cannot express it—it is too bad for words," wrote Cherry-Garrard. Two pairs of skis and a bamboo stick—the mast of the sledge—poked out of the snow near the buried tent. Inside the men seemed asleep. Scott lay in the center, with Wilson—his hands folded over his chest—on his left and Bowers on his right. Scott had thrown back the flaps of his bag and his left hand was stretched over his good friend Wilson. He had apparently rigged a lamp using a can, some remaining spirit, and a piece of his finnesko as a wick, in order to keep writing until the end.

The search party was shocked that everything was there—diaries, meteorological logs, and the thirty pounds of geological specimens. As a memorial, Atkinson read from Corinthians, prayers were said, and Scott, Bowers, and Wilson were buried in their sleeping bags, "a grave which kings must envy," Cherry-Garrard wrote. They also built a cairn and a cross over the grave, leaving a note commemorating the men's fatal journey. The search party looked to no avail for Oates' body, and left a cairn and cross near where he likely died.

The search party returned to Cape Evans in late November to the first piece of good news in many months: Campbell's party had returned alive. After seven months in the igloo, warmer weather had finally allowed them to sledge the 230 miles back home.

As summer continued with no sign of the *Terra Nova*, the men began to prepare for a third winter on the ice. But on January 18, 1913, she appeared. Lieutenant Evans, who had recovered from scurvy, shouted from the ship to Campbell on shore, "Are you all well?" Campbell responded that the polar party had made it to the Pole, but then died. A weighty hush settled on the ship.

Before leaving Ross Island, the last of the expedition members erected a cross on Observation Hill, near Hut Point, and inscribed it with the last line of Alfred Tennyson's *Ulysses*: "To strive, to seek, to find, and not to yield." After three exhilarating and tragic years, the expedition was over. Cherry-Garrard left Cape Evans "with no regret: I never want to see the place again. The pleasant memories are all swallowed up in the bad ones."

PART 9

Ross Sea Party

Within two years, the hut would shelter another Antarctic expedition: Shackleton's Ross Sea Party of his Imperial Trans-Antarctic Expedition. With the Pole spoken for, Shackleton had embarked on another quest—traversing the Antarctic continent from coast to coast. In January 1915, the ship *Aurora* arrived at Cape Evans. The Ross Sea Party planned to use the building as a base for two summer seasons' sledging trips to lay supplies along Shackleton's route. However, both sledging seasons were beset with problems—on the first, the men overloaded the sledges and exhausted the dogs, which began to die en route. What's worse, during their first winter, the *Aurora* blew out to sea in a blizzard, leaving the party stranded and fearful that the ship and her crew had been forever lost. The damaged *Aurora* eventually made it back to New Zealand, where she was repaired for a rescue expedition. Meanwhile, though the ship was gone, the men at Cape Evans decided to press on with the second season's supply-laying expedition. During this sledging trip, some of the team got sick, and Reverend Arnold Spencer-Smith died of scurvy despite the heroic efforts of his companions. Little did the struggling Ross Sea Party know that the depots—and its toil—were for naught. On the other side of Antarctica, Shackleton had not yet begun, and would never begin, his journey. His ship *Endurance* had sunk after months crippled in ice in the Weddell Sea, forcing Shackleton and his crew to abandon ship. Shackleton's resulting efforts to secure help are considered some of the most astonishing stories of survival in Antarctic history.

Once safely back at Hut Point, the weary sledge teams realized that the ship had not returned and that they were stuck in the spartan shelter at Hut Point until the sea ice froze. For the next seven weeks the party at Hut Point subsisted on seal in temperatures barely above freezing. A small group of men were in the same bind at Cape Evans, but in the more comfortable building. In May two men, Captain Aeneas Mackintosh and Victor Hayward, attempted to cross McMurdo Sound to Cape Evans too early in the season and were likely carried out to sea on an ice floe to their deaths. Once summer arrived, the remaining party at Hut Point returned to Cape Evans, and on January 10, 1917, the repaired *Aurora* arrived, with Shackleton as a passenger, and rescued the men.

Captain Scott's *Terra Nova* hut was shuttered—and with it, the heroic age of polar exploration.

41

Conclusion

When news of Scott's death hit England in 1913, a media frenzy soon catapulted him into a hero. Pictures of his widow and son appeared all over the newspapers, and many columnists gushed about his courage. For a country on the cusp of World War I, such a dramatic tale of bravery and sacrifice fit perfectly within a new patriotic mind-set.

Stories of the expedition also had what British historian Max Jones, of the University of Manchester, calls a "*Titanic* factor": For instance, audiences of the 1997 movie knew the doomed ship's fate beforehand, but still were gripped by the film. Likewise, said Jones, there's a "grim fascination and suspense as you follow Scott's journey through his diary to his death, even though you know they're not going to make it at the end."

The haunting pictures Scott and his men took at the Pole also captivated the public, making it seem like they were "coming back to us from us beyond the grave," said Jones, who edited the 2006 Oxford World's Classics edition of Scott's expedition journals. What's more, Scott's "Message to the Public" appealed to a culture already fond of famous last words—especially when written so well at death's door.

All told, a relief fund in England raised 75,000 British pounds—about 3.3 million pounds today—in part to provide for the loved ones of the dead, as Scott had wished.

However, the lofty image of Scott as a legend of the British empire began to crumble as people started questioning his status as an explorer. In Cherry-Garrard's *The Worst Journey in the World*, published in 1922, he described Scott as moody and humorless, subject to disabling bouts of depression, and generally a weak man.

Yet Cherry-Garrard also described these faults to suggest that Scott overcame them: "What pulled Scott through was character, sheer good grain, which ran over and under his weaker self and clamped it together."

In 1928, James Gordon Hayes's *Antarctica: A Treatise on the Southern Continent* criticized Scott's decision not to take dogs throughout the journey. Most historians agree that dogs were crucial to Amundsen's success.

In 1977, British historian David Thomson's book *Scott's Men* suggested that Scott was not a "great man" and that his "journey had less practical purpose than an appeal to the imagination."

Anti-Scott sentiment reached its zenith in 1979 with Roland Huntford's *Scott and Amundsen*, which made point-by-point comparisons of the two explorers to the detriment of Scott. The British author's "hatchet job" on Scott, Jones said, asserted that Scott was a mean-spirited, inept explorer whose poor planning on the journey made him responsible for the deaths of his colleagues.

Huntford's book was powerful because he did extensive archival research on both explorers—aided by his knowledge of Norwegian—as well as criticized Scott more savagely than anyone had before. Huntford's take on Scott would set the tone and public perception of the explorer as a bungler for the next quarter century.

Scott's downfall in the 1970s was also linked to Britain's loss of power as an empire. For instance, a common view "was that Britain had been ruined by incompetent...school boys who valued playing the game rather than winning," Jones said. "Scott then gets positioned as part of that story—he's emblematic of the broader failings of the ruling elite in Britain that led to British decline in the 20th century."

Meanwhile, Scott's time in the spotlight had mostly relegated his rival Ernest Shackleton to the shadows of Antarctic history. But that began to shift in the 1990s—especially in the United States—thanks to a 1999 exhibit on Shackleton's *Endurance* expedition in New York City. The exhibit's accompanying book, *The Endurance* by Caroline Alexander, and the 2002 Kenneth Branagh television film *Shackleton*, also sparked renewed interest in the rugged explorer.

"Shackleton's resurgence was due to the fact that he better fit the image of the post-Vietnam super-macho, rebellious-but-ultimately patriotic, anti-hero that became popular in the 1980s and '90s à la Rambo, John McClane in *Die Hard*, and Martin Riggs [of *Lethal Weapon*]," noted Stephanie Barczewski, professor of modern British history at Clemson University.

In general, Shackleton's fame helped push Scott aside, especially in the United States, where few people know of Captain Scott's story even today, added Barczewski, author of *Antarctic Destinies: Scott, Shackleton, and the Changing Face of Heroism*.

However, in recent years Scott's reputation has been somewhat restored. In 2001, U.S. atmospheric scientist Susan Solomon published *The Coldest March*, which offered detailed research showing that the Ross Ice Shelf was unusually frigid in the summer of 1912, during Captain Scott's fateful return journey. And in 2004, British polar

explorer Ranulph Fiennes published *Race to the Pole*, what Barczewski calls a "spirited defense" of Scott. The book, dedicated to "the families of the defamed dead," sought to rebut many parts of Huntford's book.

Today, after the publication of several biographies of Scott, many historians are trying to take a more balanced view of the explorer—as a man of his times, bound up in Royal Navy traditions, as well as a strongly resilient individual who displayed both good and bad judgment and who was plagued by bad luck and extraordinary weather.

Thomson, for instance, gave a more holistic interpretation of Scott in his 2002 updated edition of *Scott's Men*, titled *Scott, Shackleton and Amundsen*: "Twenty-five years have passed. And I hope that now it is possible to regard Scott as a whole—to see the valor and the eloquence, as well as the spite, the depression, and the failures of command."

Likewise, in 2005, British historian David Crane's biography *Scott of the Antarctic* delivered a fresh and more nuanced perspective, gleaned from Crane's unlimited access to the explorer's papers, diaries, and expedition records.

Overall, the debate swirling around Scott as a man and a leader has obscured the expedition's accomplishments, especially in science and photography.

In 2011, the Antarctic Heritage Trust, the Natural History Museum in London, and the Canterbury Museum in Christchurch, New Zealand, produced an exhibition that sets out to bring to light much of the forgotten scientific and other achievements of Scott's last expedition.

The scientific research conducted during the expedition was in many ways groundbreaking, simply because it was unprecedented. Much of the atmospheric and meteorological data has given scientists a baseline against which to compare their own results decades later. These experts identified hundreds of new species and wrote scores of scientific papers and reports. Many *Terra Nova* scientists, including George Simpson, T. Griffith Taylor, Frank Debenham, and Raymond Priestley, also went on to become leading experts in their fields.

"They were driven not only by a patriotic desire to get to the Pole first for the British empire...but also by a passion to discover more about the world," Jones said.

Or, as Cherry-Garrard plainly put it: "We traveled for science." In his book, Cherry-Garrard often juxtaposes the Norwegian and British expeditions as opposites—

Amundsen on a businesslike there-and-back journey, Scott on a risky research expedition with the Pole as bait for public support.

The *Terra Nova* expedition also made photographic advances, such as in the use of color in so remote a place. Already a pioneer in photography and cinematography, Ponting experimented with new techniques in his well-outfitted darkroom. Though he did not go on the South Pole journey, Ponting visually captured the little-known continent in a way that had never been done before or since.

Today, visitors to the *Terra Nova* hut, which still stands on Cape Evans, can peek inside the darkroom where Ponting worked and slept. His original equipment fills the small space, forever preserved as a reminder of the poignant photographs that first opened Antarctica up to the world.

BIBLIOGRAPHY

Antarctic Heritage Trust, 2004. "Conservation Plan. Scott's Hut, Cape Evans."
Cherry-Garrard, Apsley. *The Worst Journey in the World.* New York: Penguin Classics, 2005.
Jones, Max. Personal interview. May 10, 2011.
Barczewski, Stephanie. Personal interview. May 25, 2011.
Scott, Robert Falcon. *Journals: Captain Scott's Last Expedition.* Oxford: Oxford Press, 2006.
Watson, Nigel, and Jane Ussher. *Still Life.* New South Wales: Murdoch Publishing, 2010.

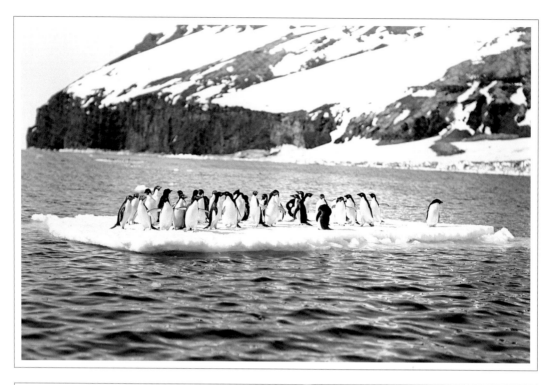

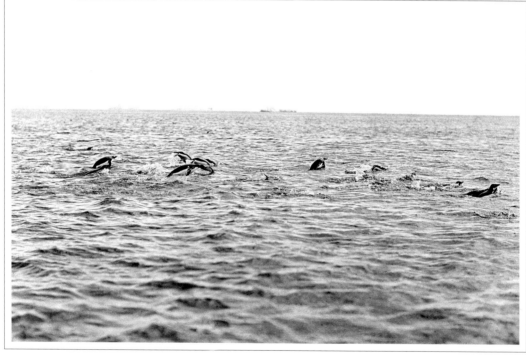

TOP: A group of penguins stands on an ice floe adrift on the sea. *BOTTOM:* Penguins swimming.
OPPOSITE: Cloud effect, Ross Sea. *FOLLOWING PAGES:* Furling the *Terra Nova*'s main sail in the pack.

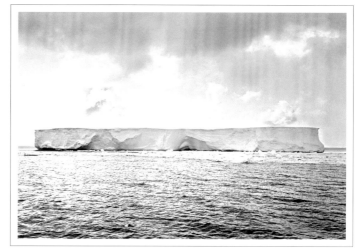

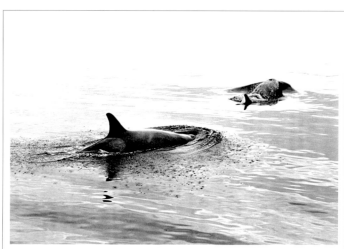

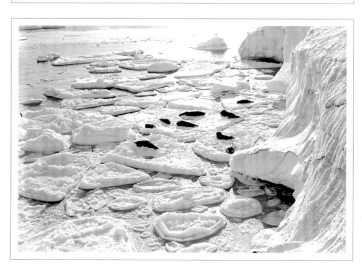

TOP: A large tabular berg, December 9, 1910. *MIDDLE:* Two killer whales break the surface of the sea.
BOTTOM: A group of seals lies on ice floes at the base of an ice cliff. *OPPOSITE:* Herbert Ponting cinematographing whales.

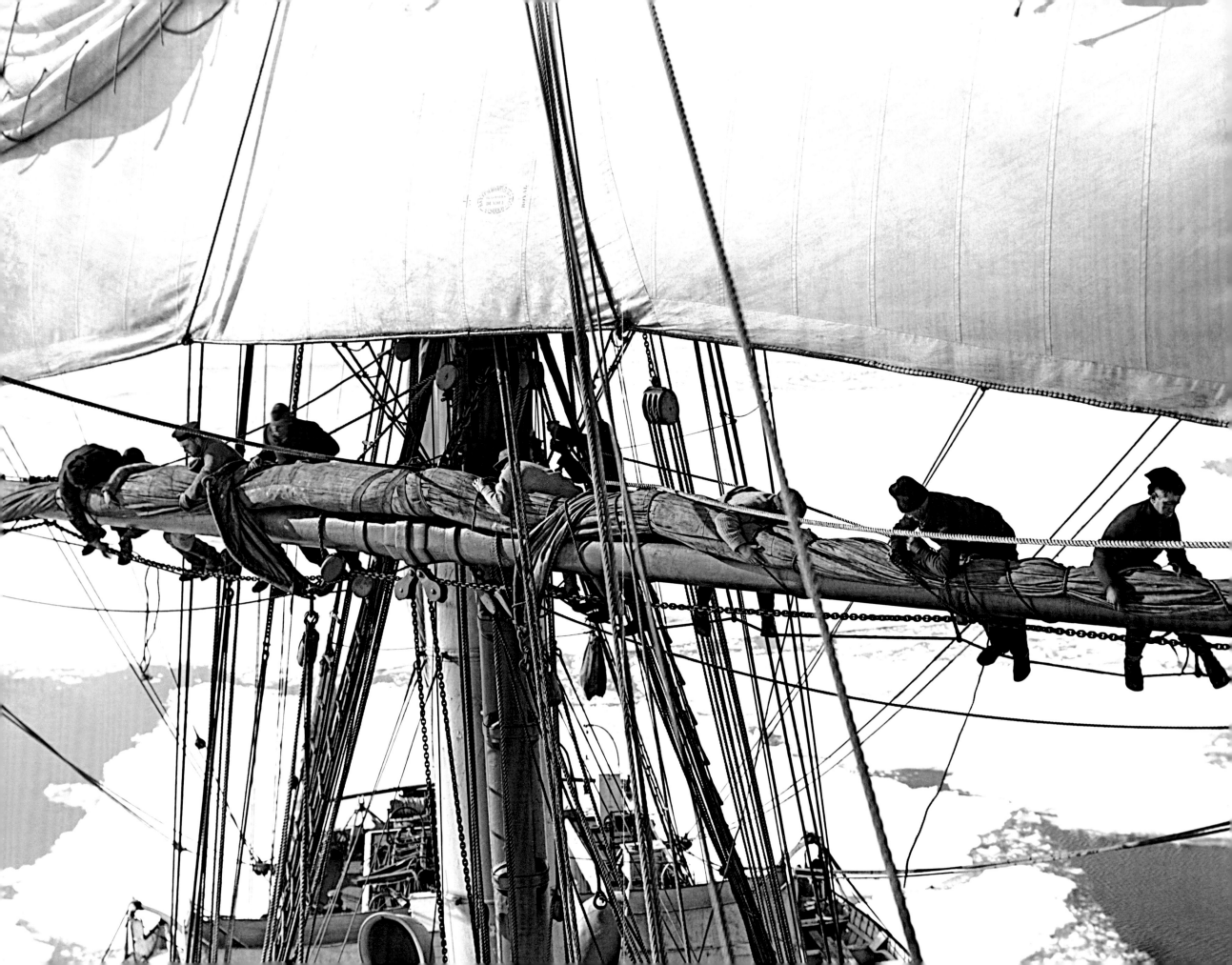

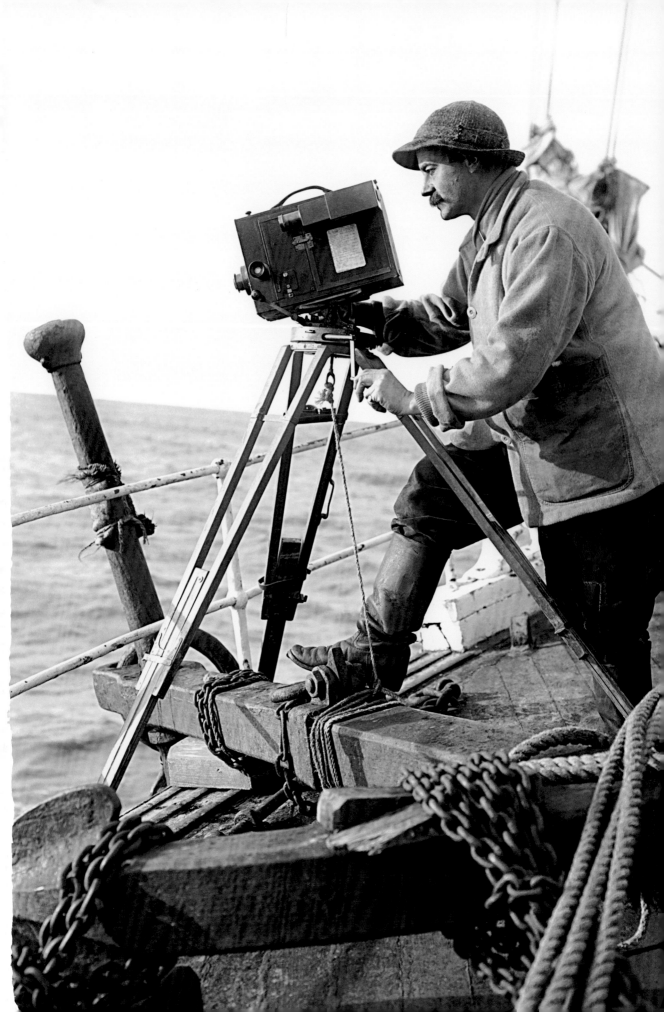

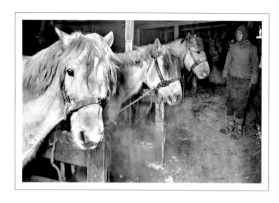

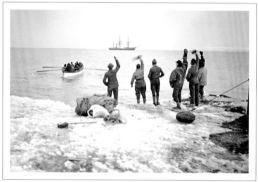

I was much disturbed last night by
the motion; the ship was pitching and
twisting with short sharp movements on a
confused sea, and with every plunge my thoughts
flew to our poor ponies.

Poor patient beasts! One wonders how far
the memory of such fearful discomfort will
remain with them — animals so often
remember places and conditions where they have
encountered difficulties or hurt.

TOP: Captain Oates and some of the Siberian ponies in the stable at Cape Evans hut. *BOTTOM:* Left behind in Victoria Land, February 9, 1911.
OPPOSITE: Terra Nova in a gale, March 1912. *FOLLOWING PAGES: Terra Nova* and a berg at ice-edge, January 16, 1911.

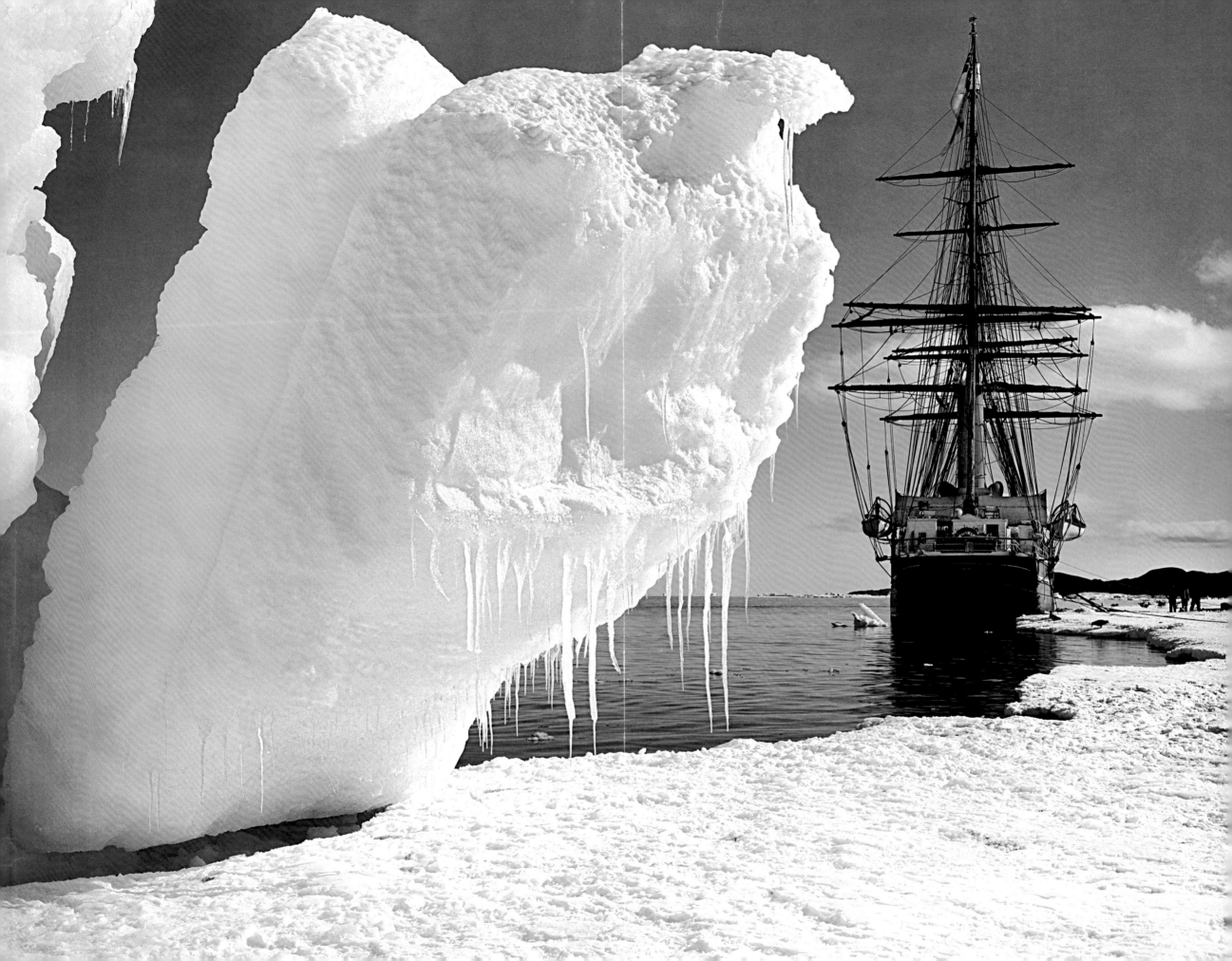

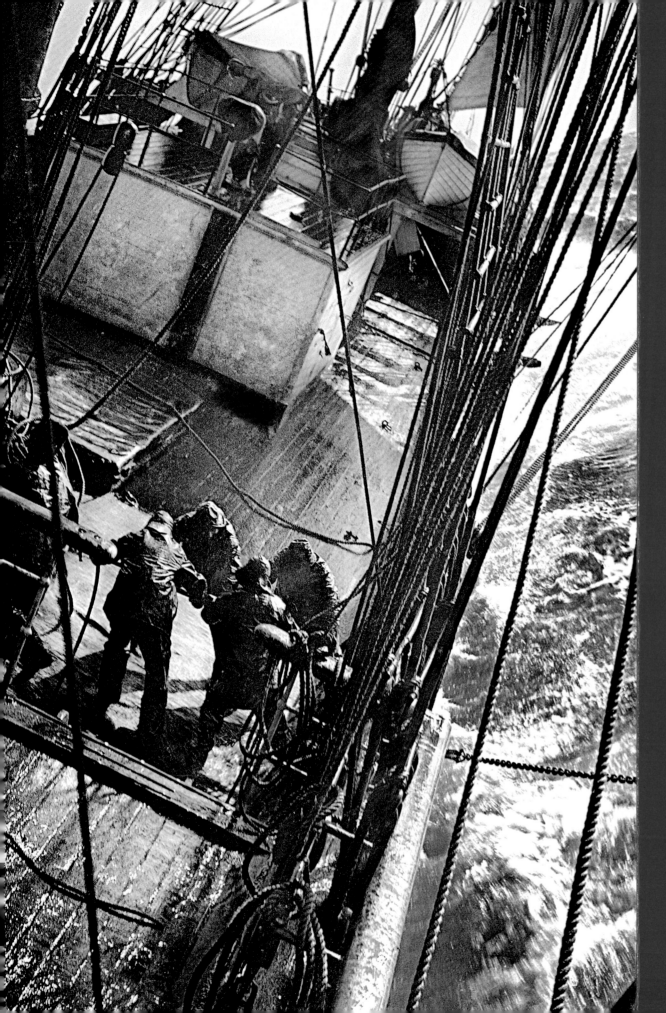

> 66 *The most anxious moment came when a pony team returning to Hut Point was almost lost at sea on McMurdo Sound's unreliable ice.* 99

A pony hangs in a sling alongside *Terra Nova*. *FOLLOWING PAGES (LEFT):* Petty Officer Keohane. *(RIGHT):* Cecil H. Meares on his return from the Barrier (as the Ross Ice Shelf was then known), January 5, 1912. *PAGE 60:* Steward Frederick Hooper on his return from the Barrier, December 21, 1911. *PAGE 61:* Charles Wright on his return from the Barrier.

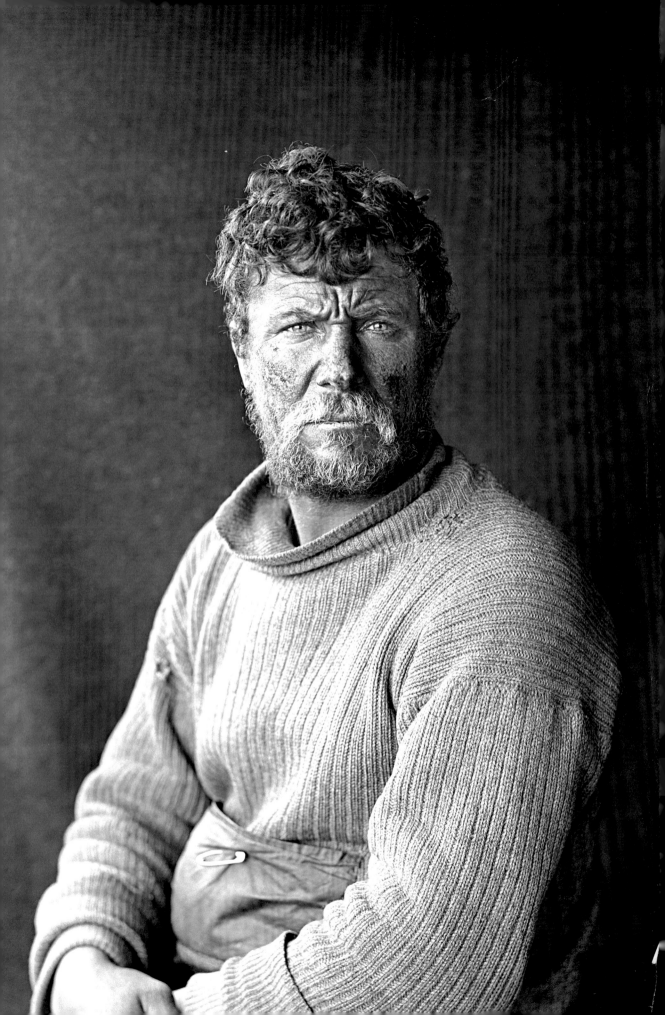

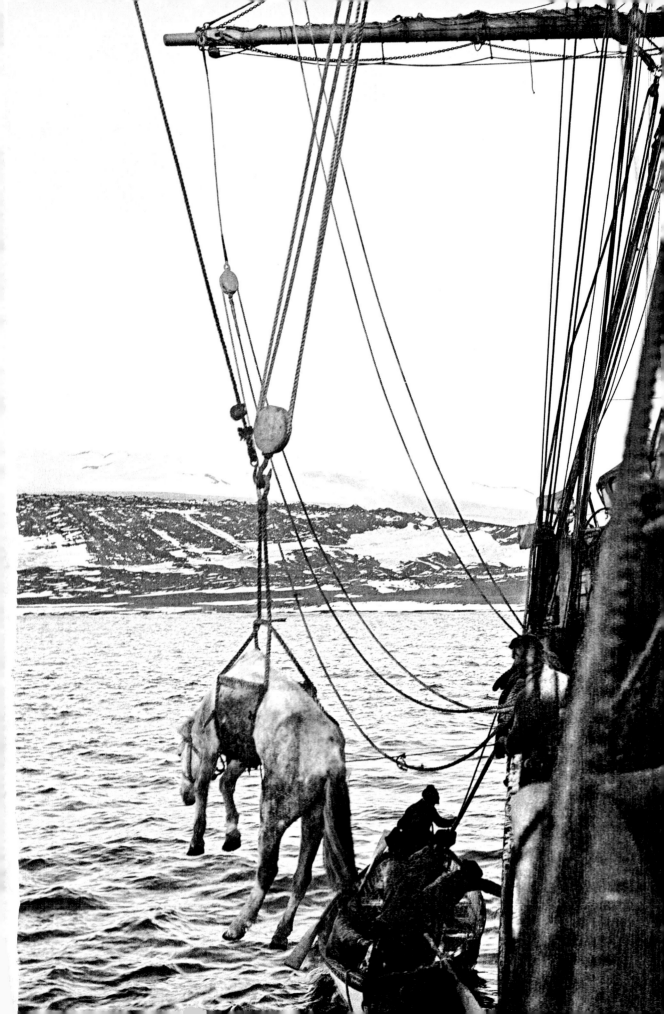

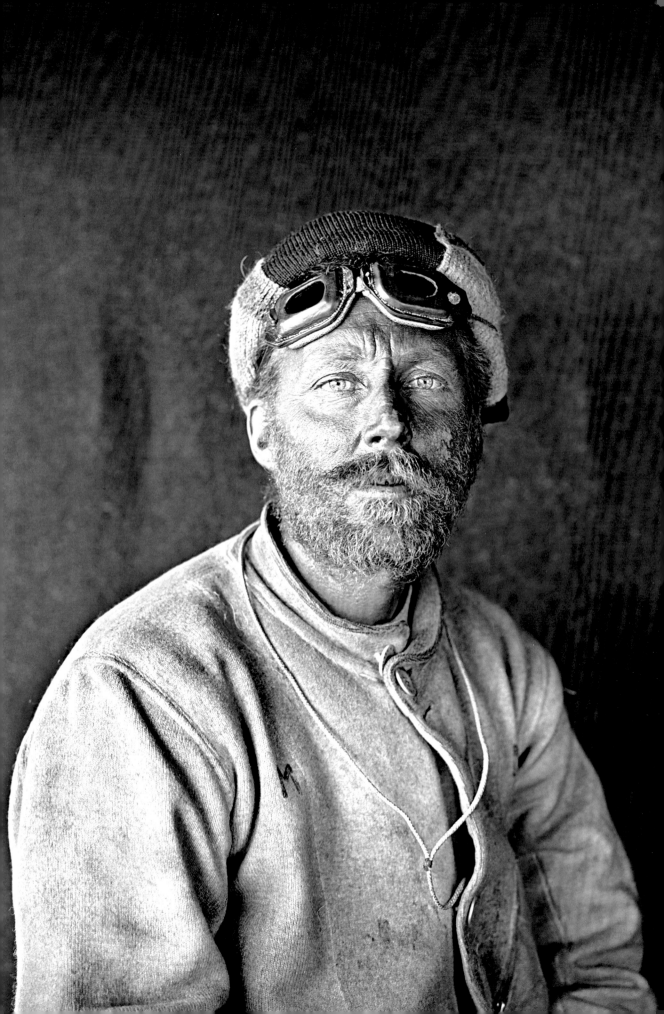

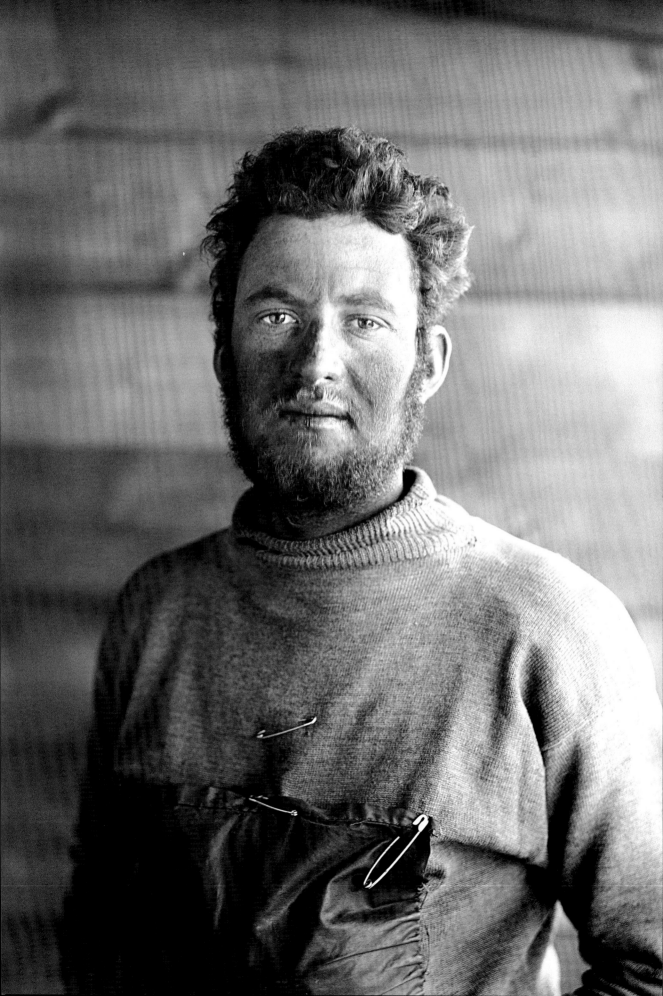

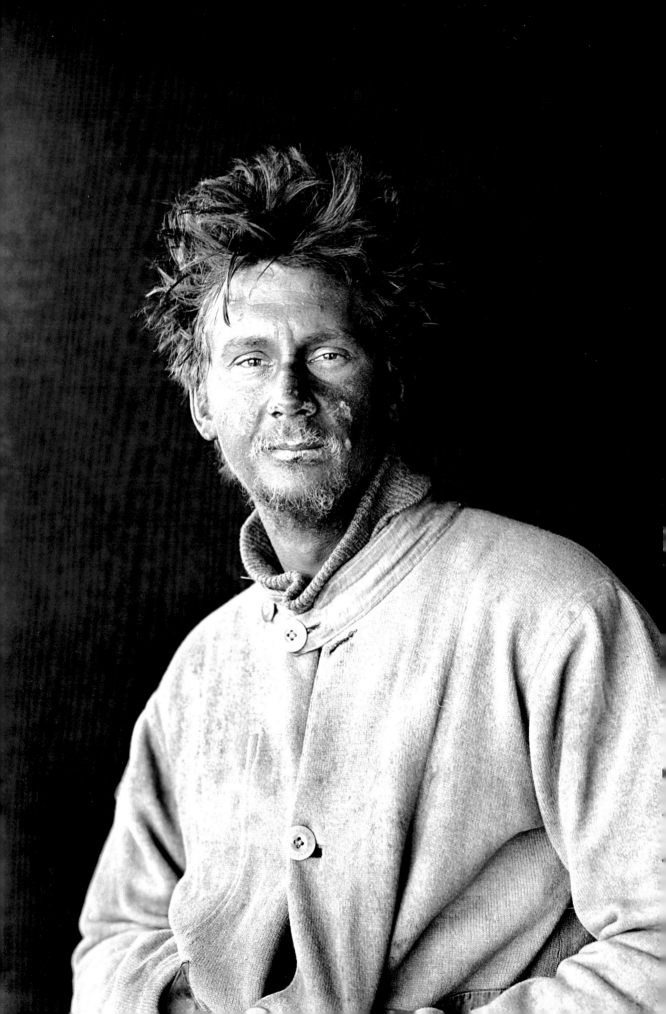

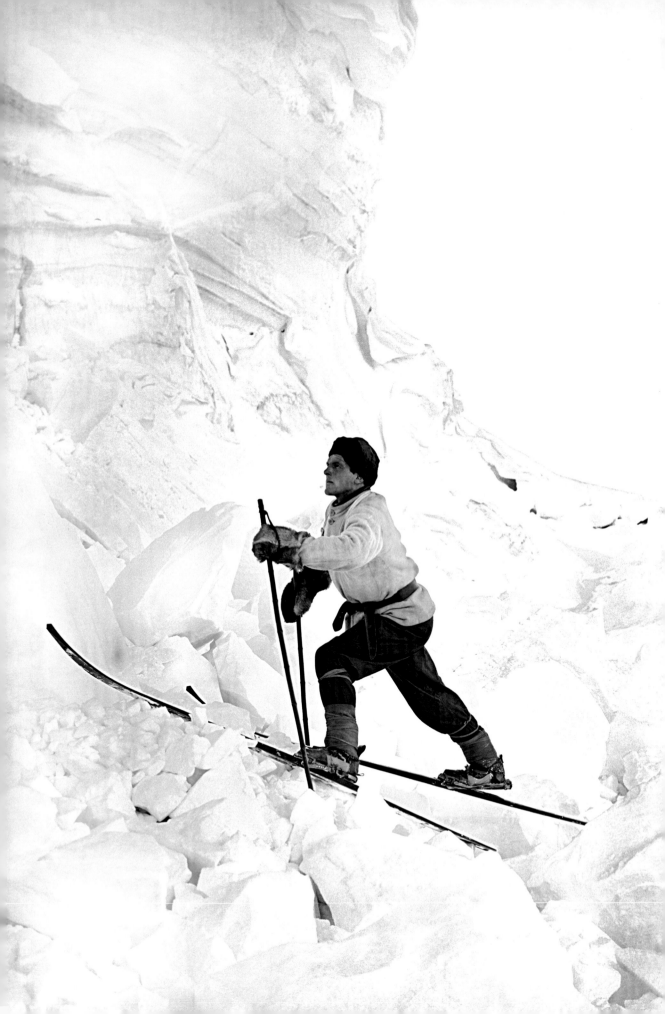

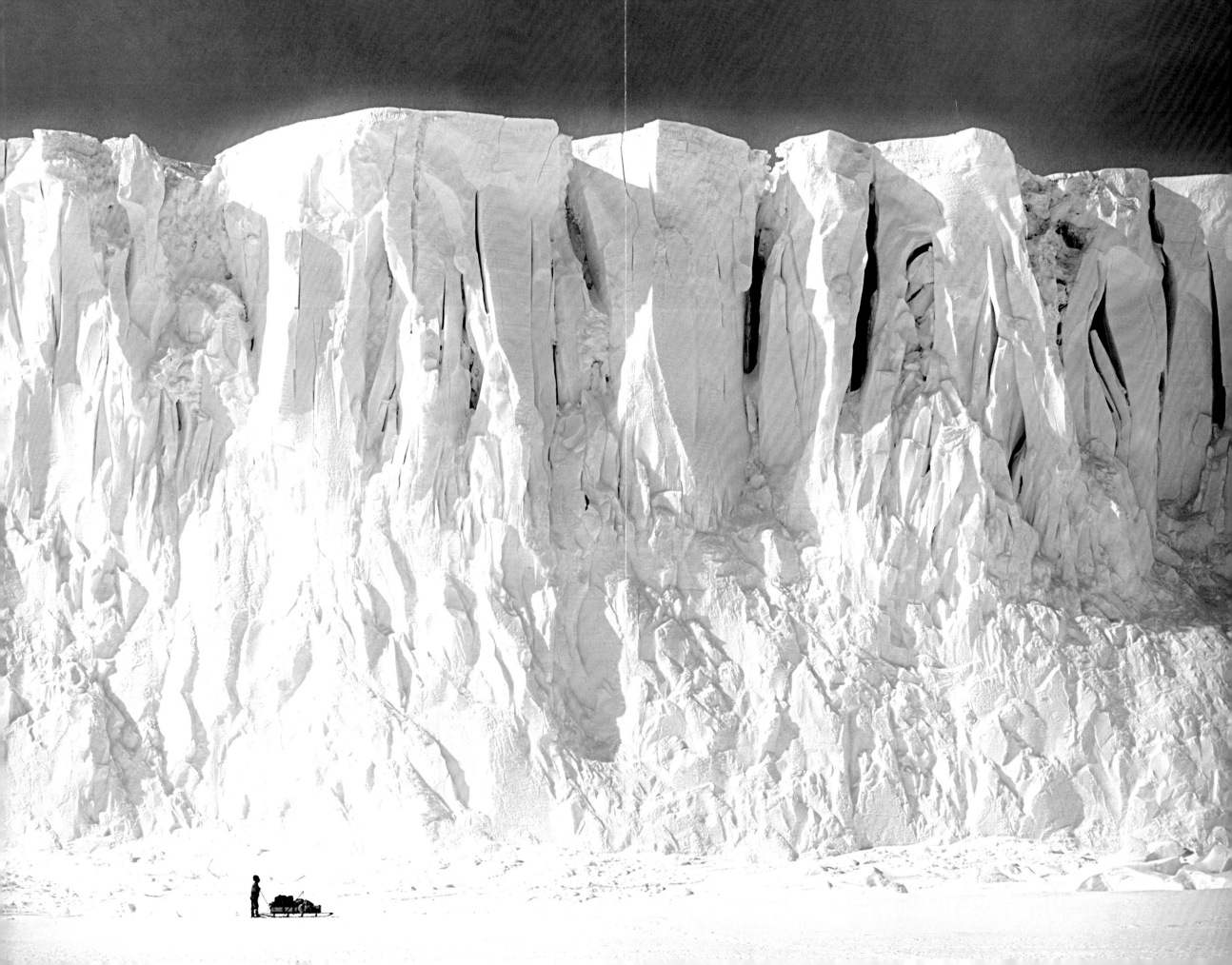

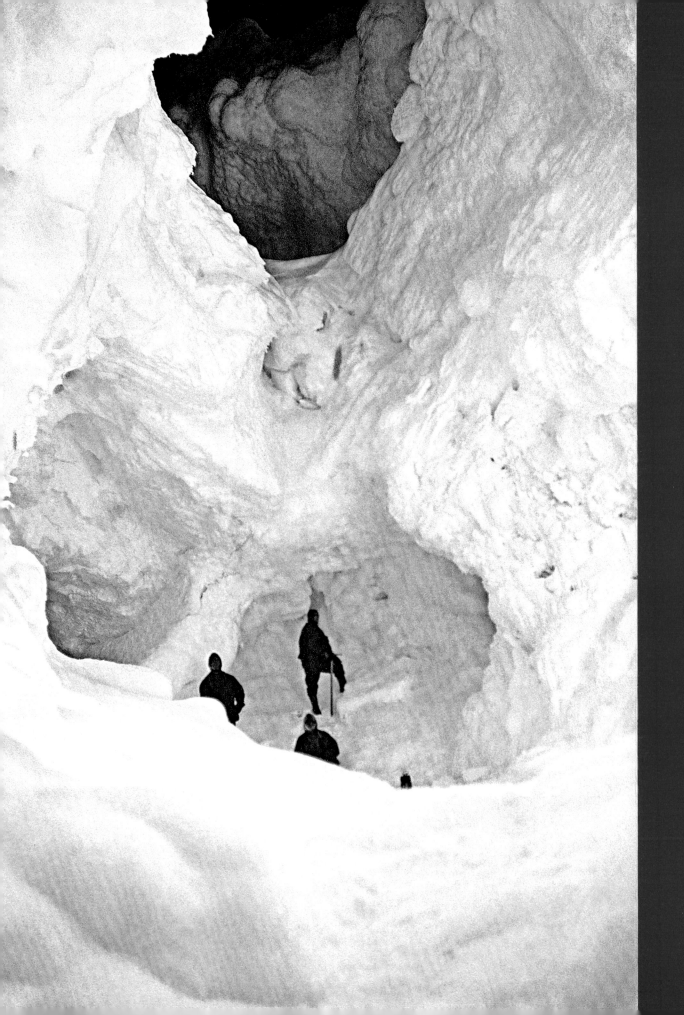

66 *As winter wore on, life slid into a predictable cadence. The scientists worked furiously, tending to meteorological observations on the sixty-six-foot-high Wind Vane Hill located behind the hut.* 99

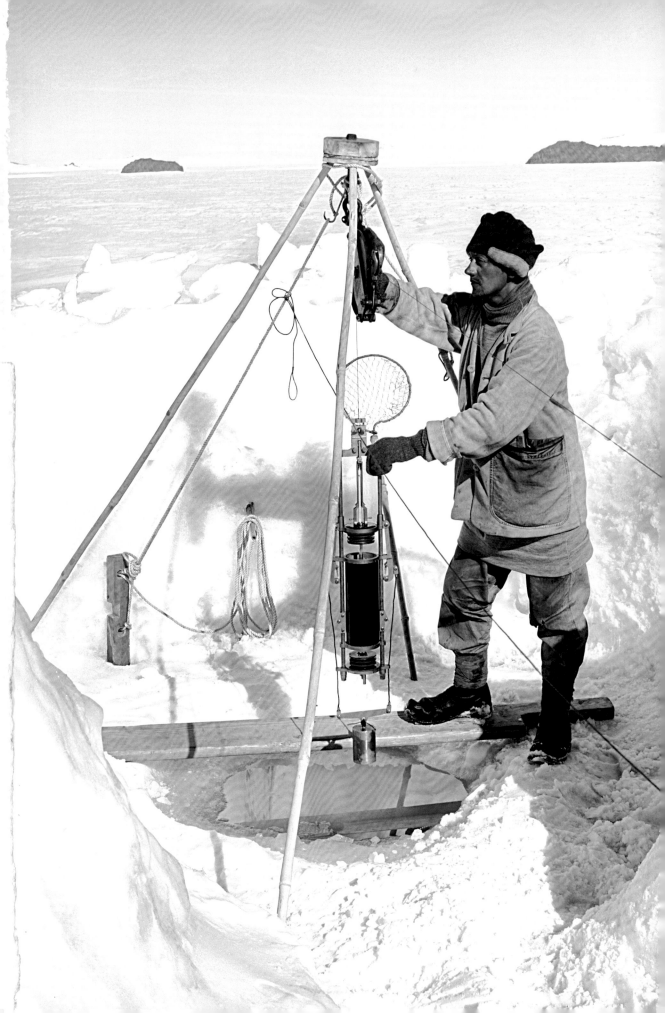

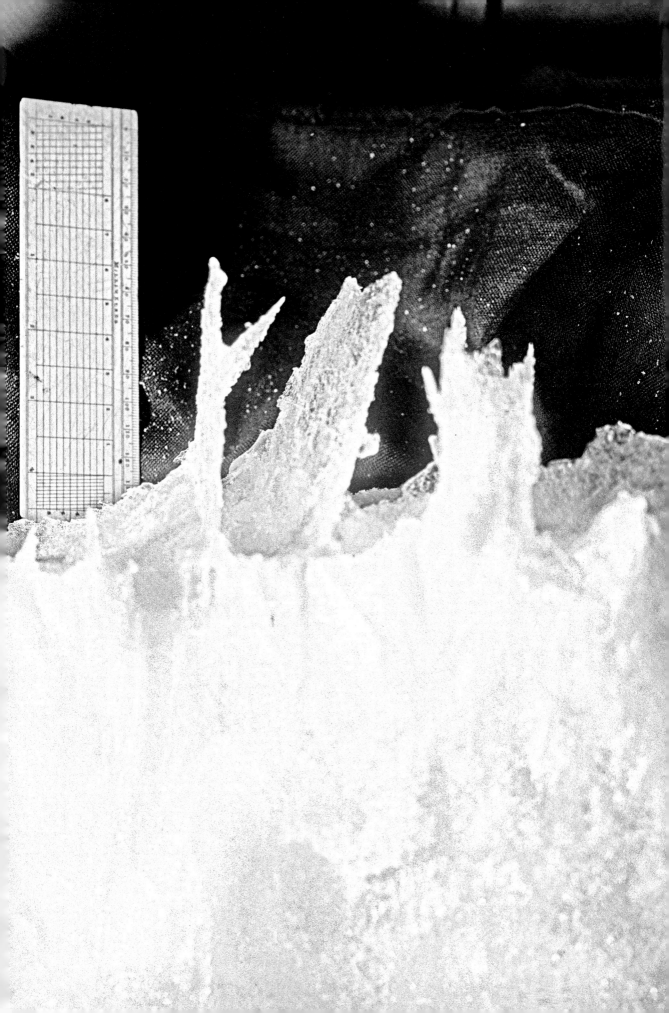

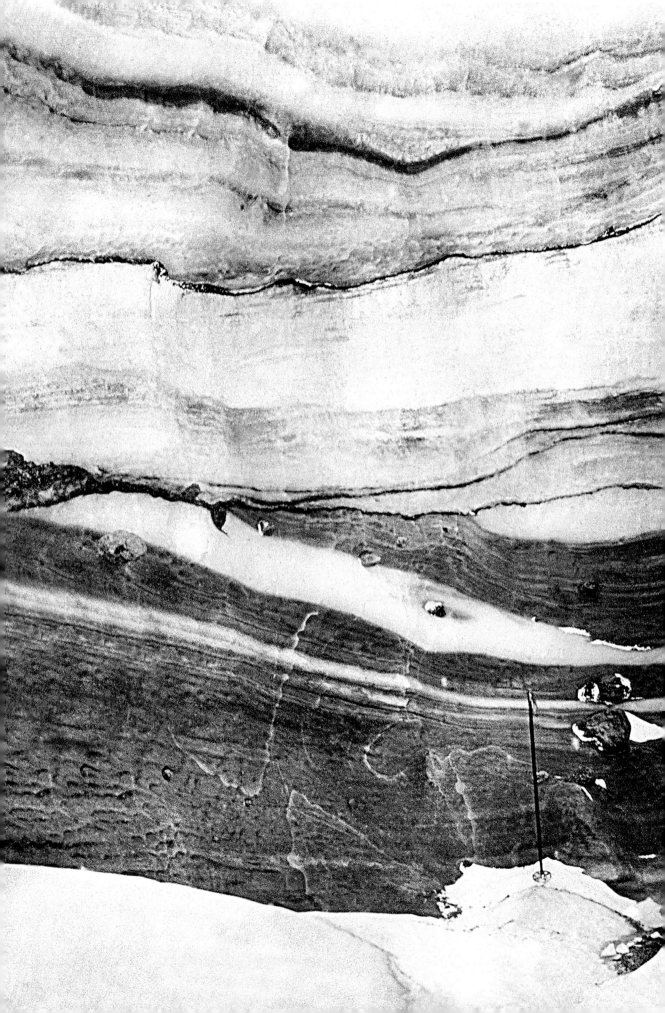

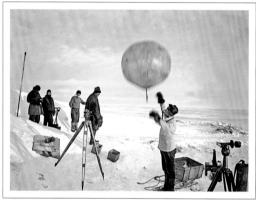

Ponting would have been a great asset to our party if only on account of his lectures, but his value as pictorial recorder of events becomes daily more apparent. No expedition has ever been illustrated so extensively.

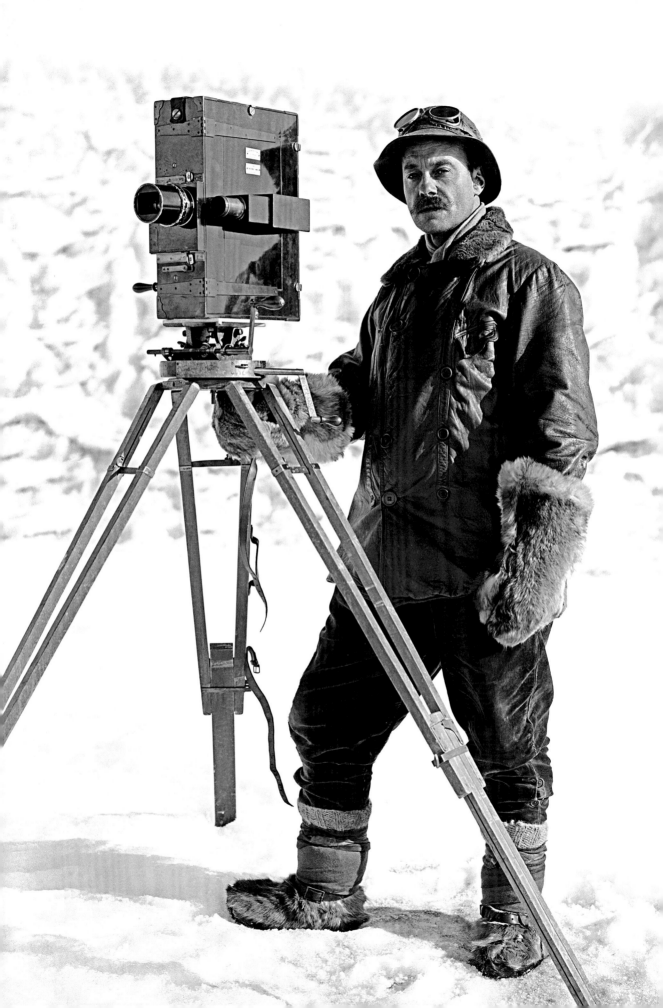

> *"Showers of ice crystals coated the snow, resulting in a sandy surface that bogged the men down."*

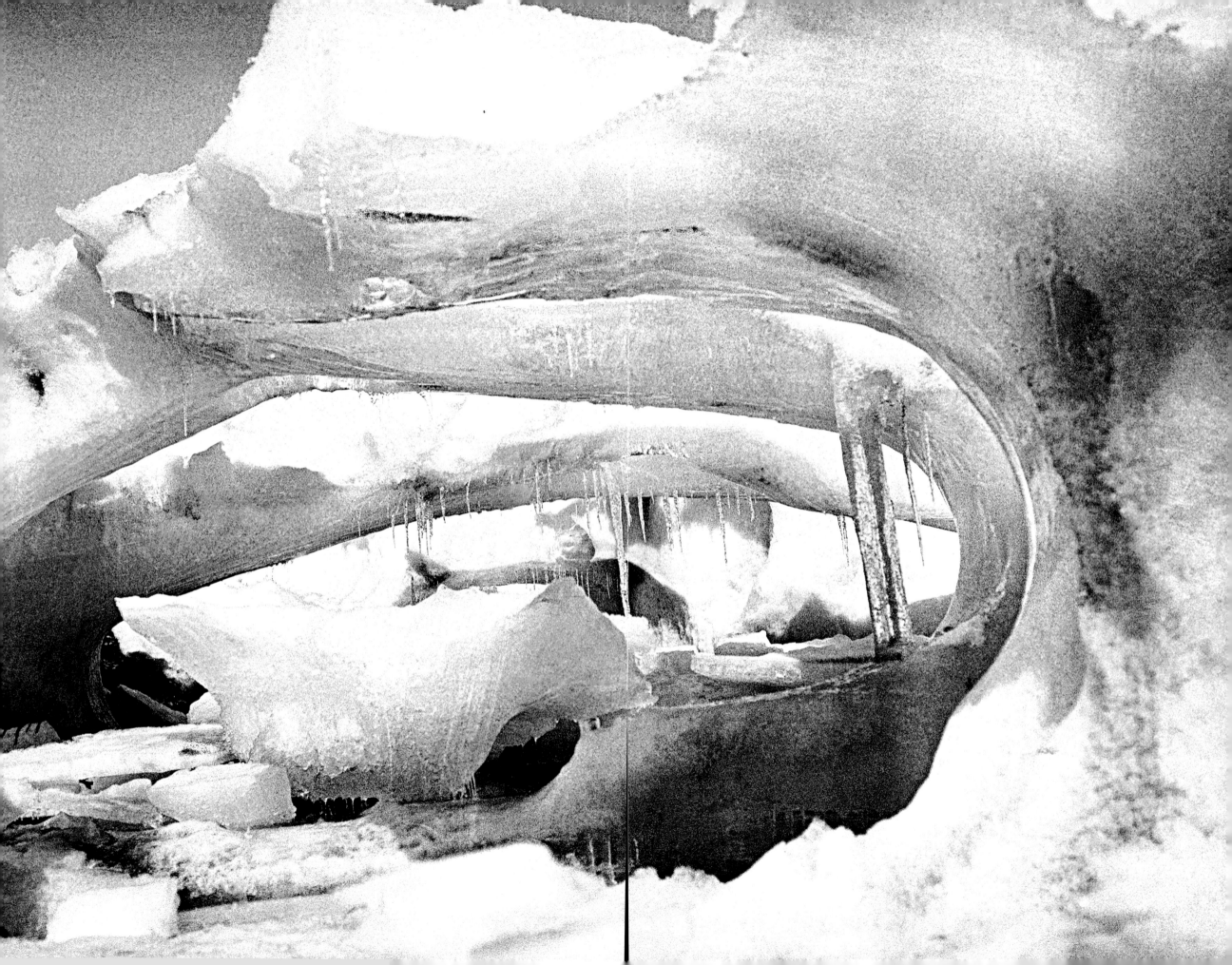

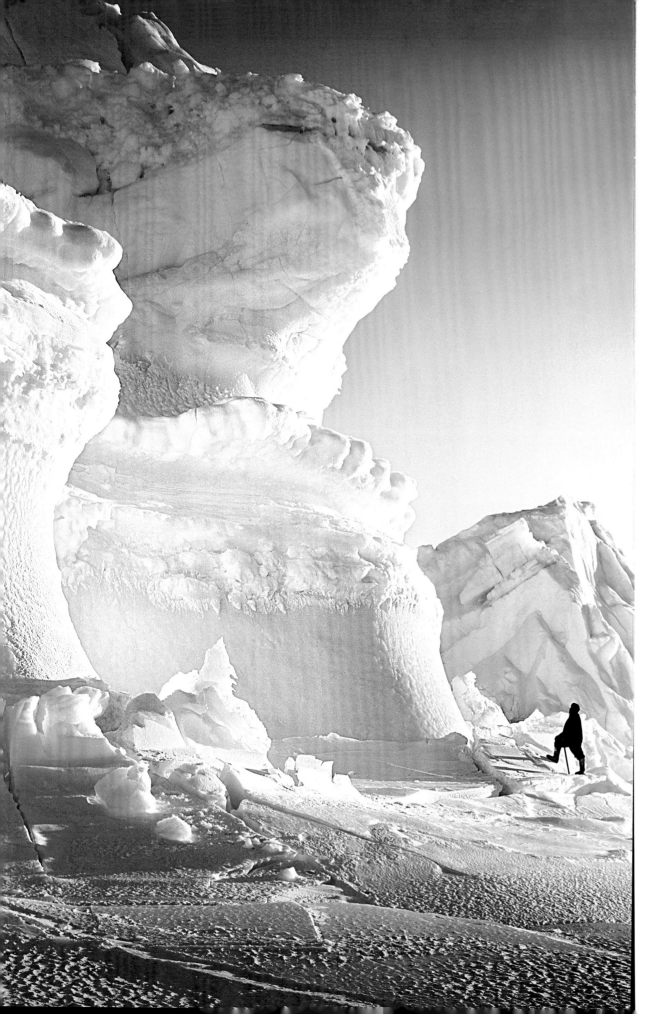

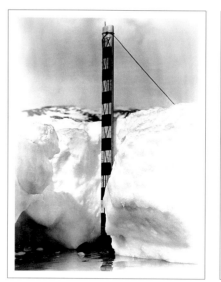

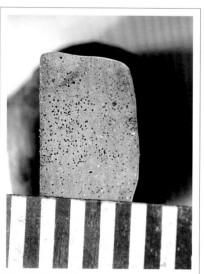

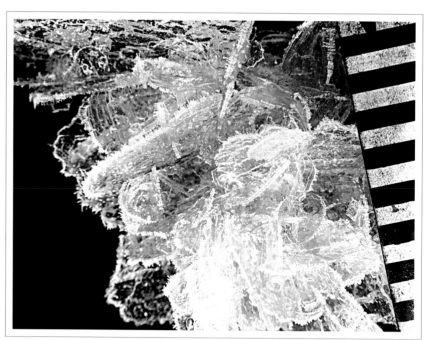

TOP (LEFT): A wooden measuring ruler stands upright against ice. *(RIGHT):* Ice from slipper lamp. *BOTTOM:* Frazie crystals outlined by frost prisms. *OPPOSITE:* Fern-shaped crystals on icicles. *FOLLOWING PAGES (LEFT):* Pyramidal turret ice crystals from Magnetic Cave. *(RIGHT):* Expedition members stand in a large, naturally sculpted ice cave.

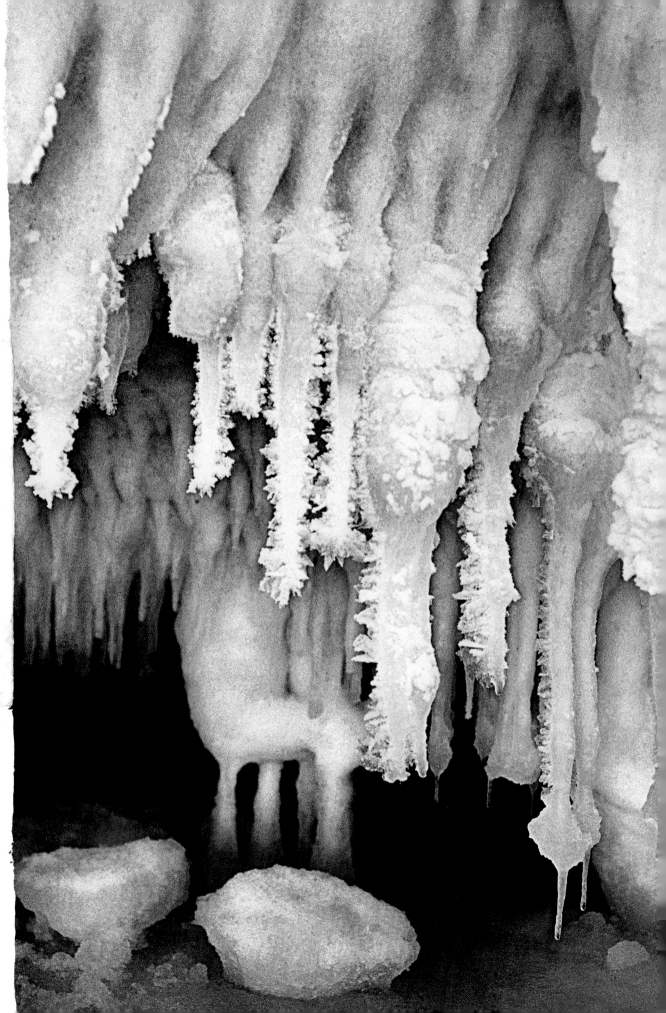

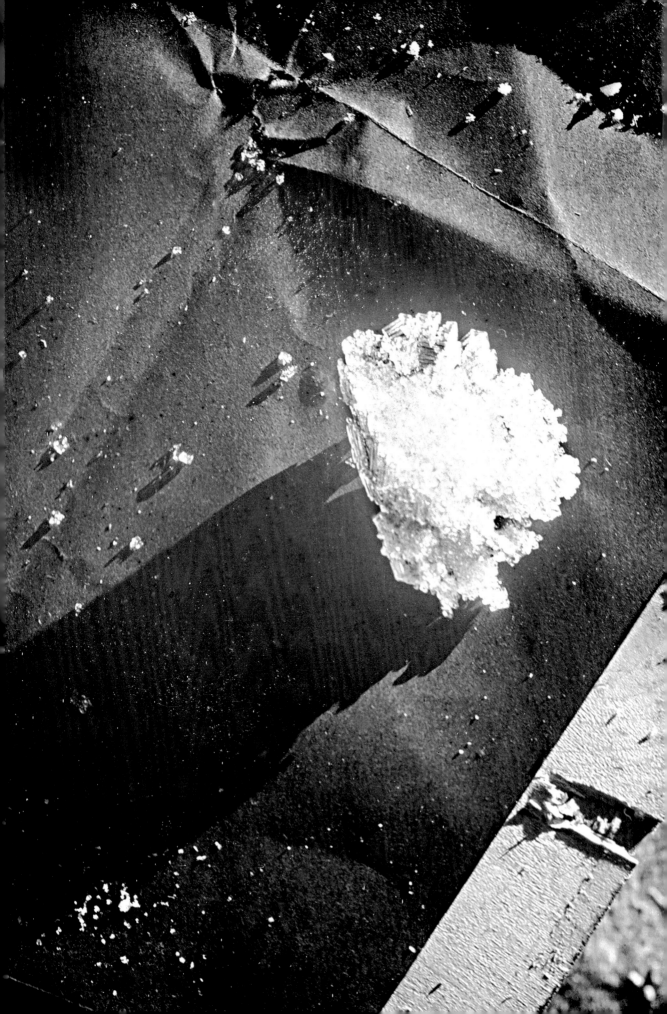

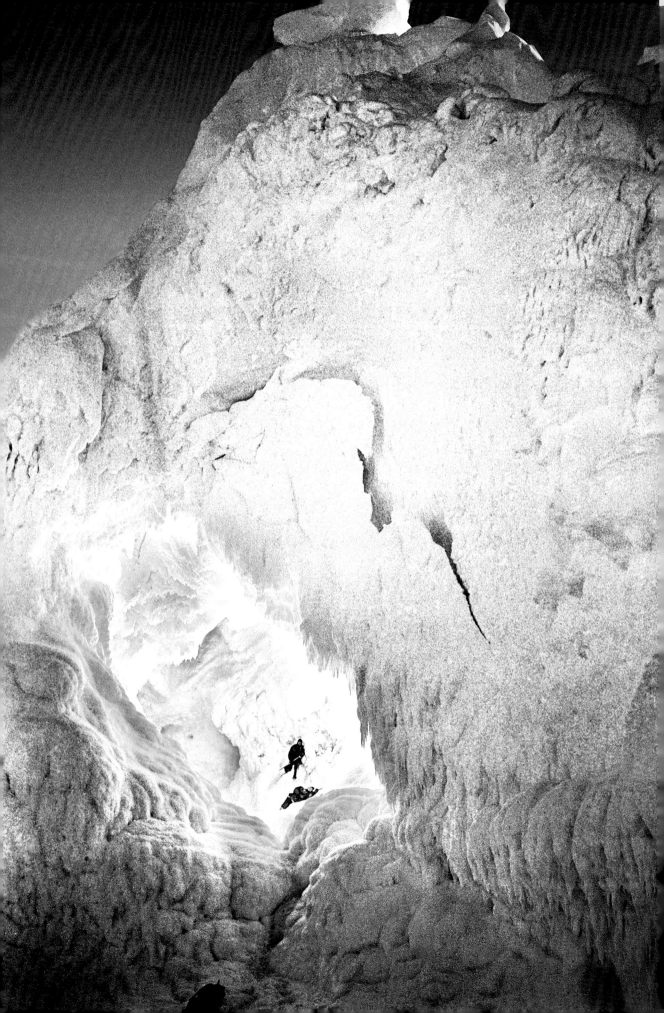

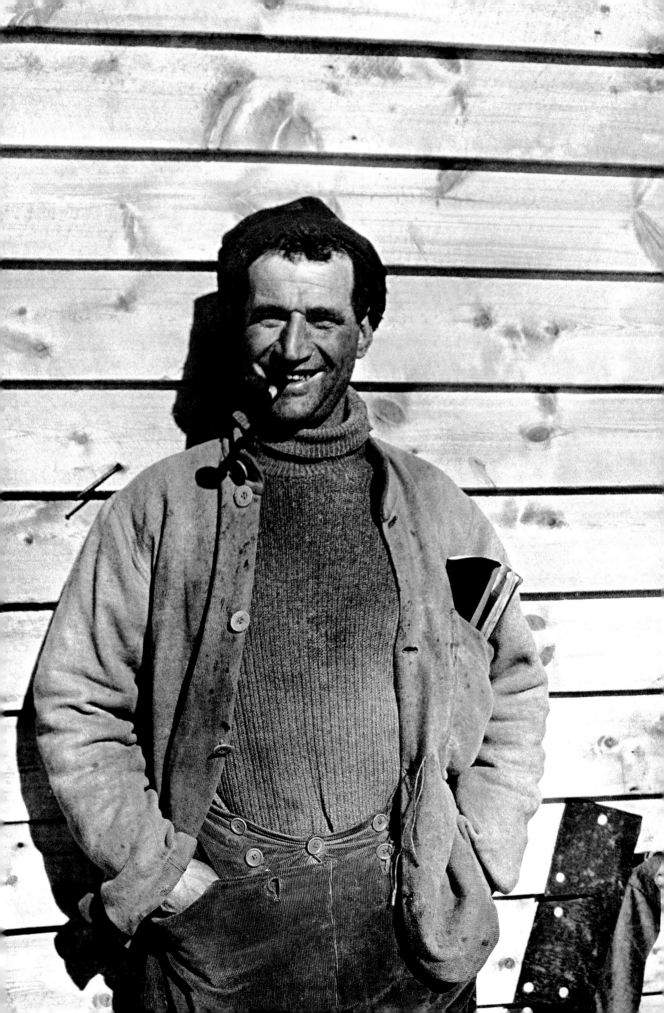

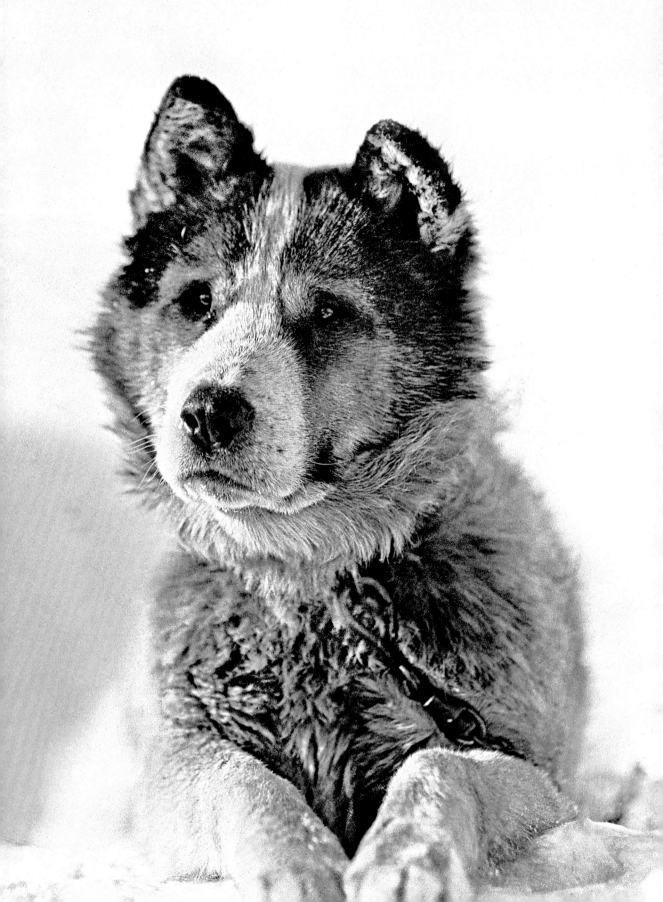

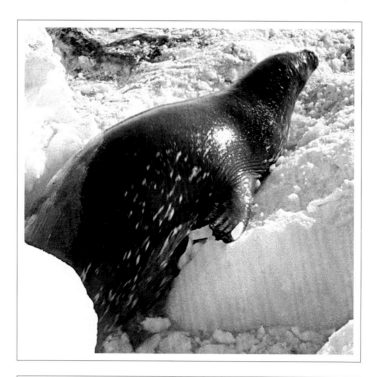

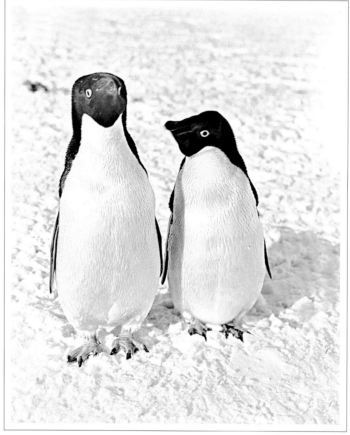

PREVIOUS PAGES (LEFT): Portrait of Crean leaning against Cape Evans hut, smoking a pipe. *(RIGHT):* Sledge dog Vida.
TOP: Seal emerging onto the ice. *BOTTOM:* A pair of Adélie penguins, January 1911. *OPPOSITE:* View of Turk's Head, with the edge of a glacier in the foreground. Seals lie on ice in the middle distance. *FOLLOWING PAGES:* Penguins slide away from the camera on the ice.

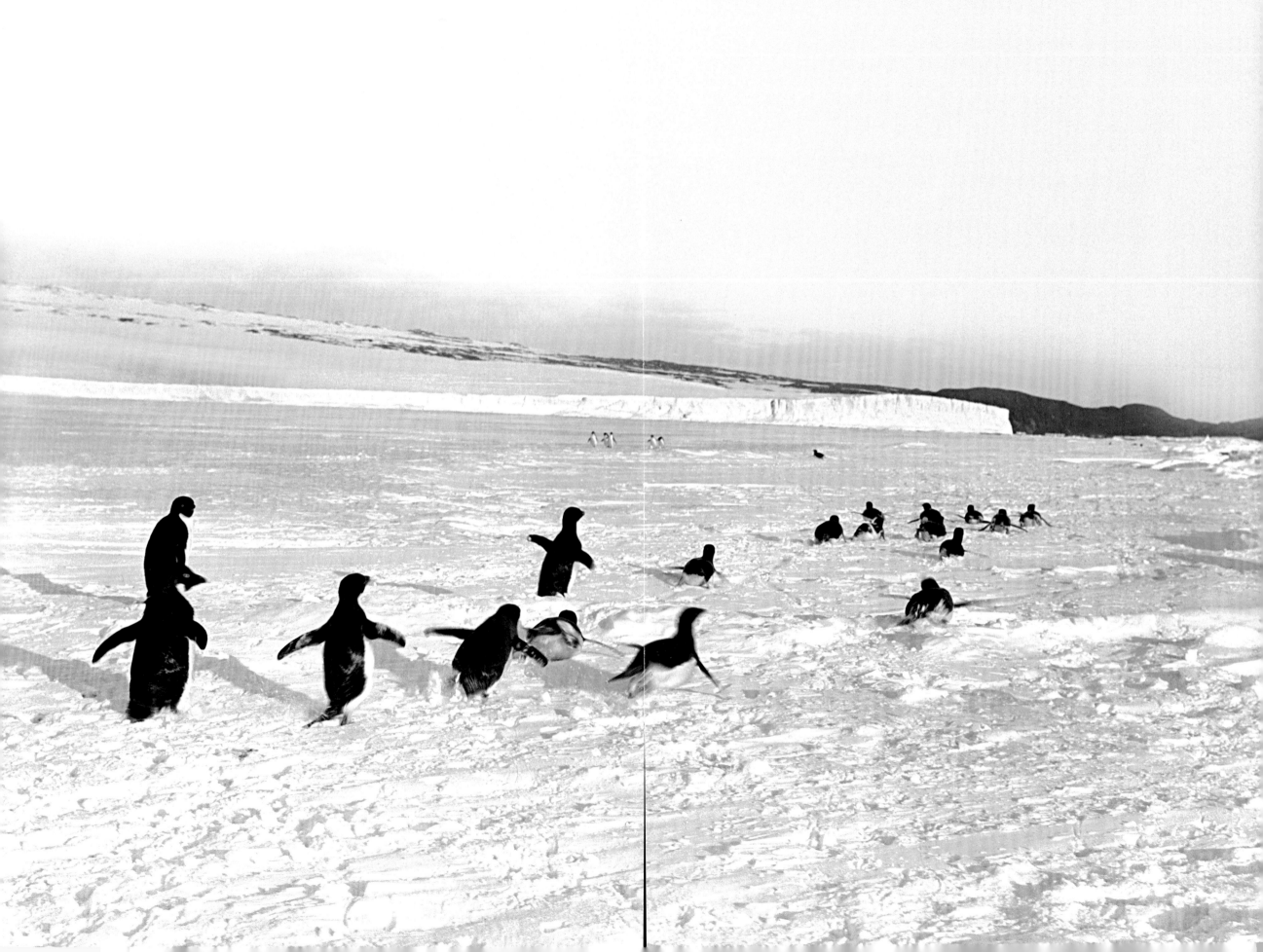

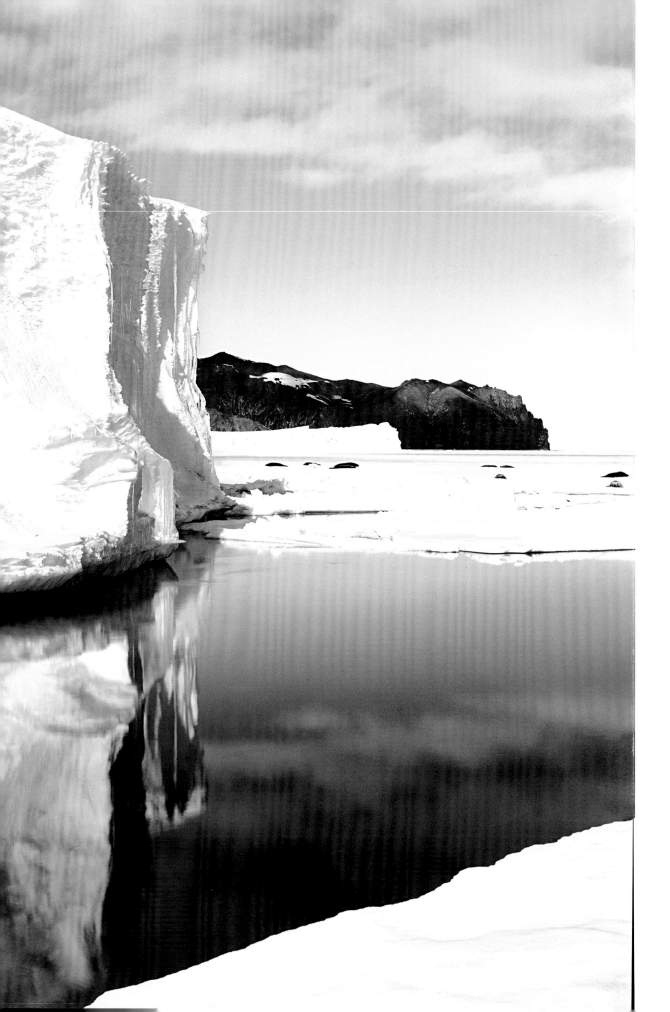

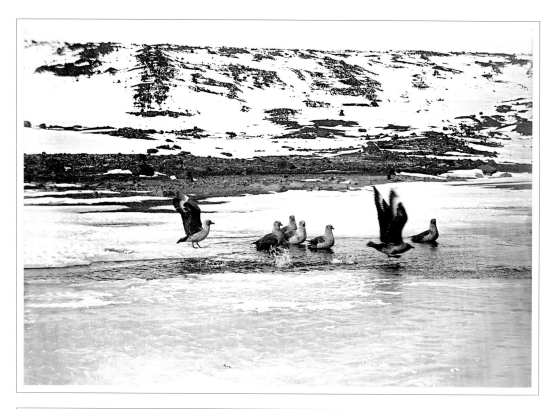

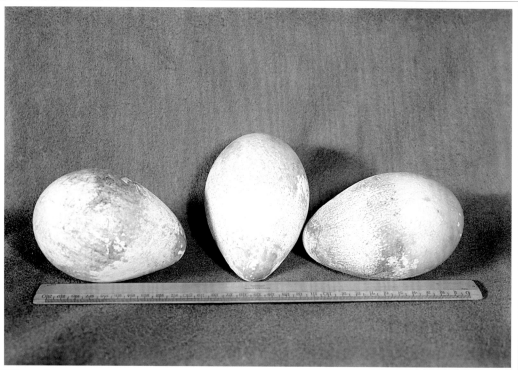

TOP: Antarctic skua gulls bathing in a lake, January 1912.
BOTTOM: Three emperor penguin eggs, with a ruler for scale.

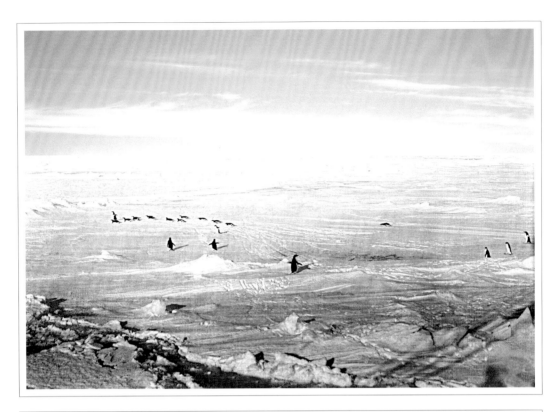

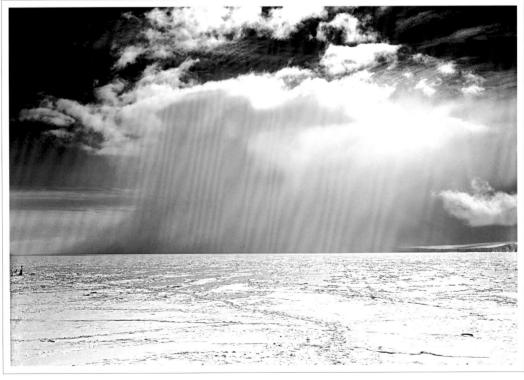

TOP: Adélie penguins on a frozen sea.
BOTTOM: Cloud buildup over a snowfield.

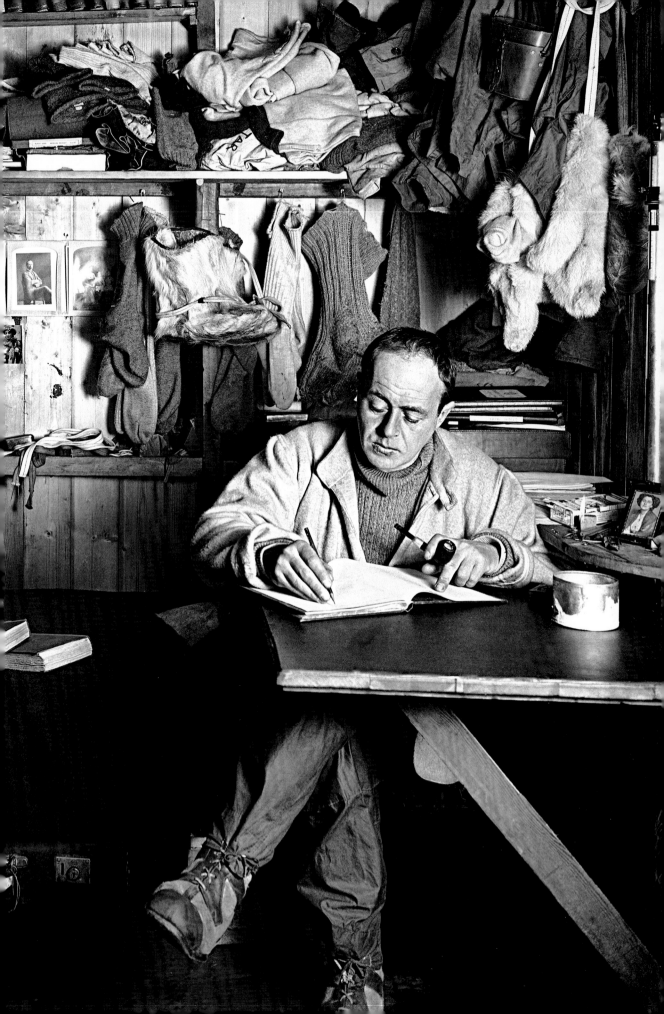

Stores left in depôt:

Lat. 79° 29'. Depôt.

lbs.

245 7 weeks' full provision bags for 1 unit

12 2 days' provision bags for 1 unit

8 8 weeks' tea

31 6 weeks' extra butter

176 lbs. biscuit (7 weeks' full biscuit)

85 8½ gallons oil (12 weeks' oil for 1 unit)

850 5 sacks of oats

424 4 bales of fodder

250 Tank of dog biscuit

100 2 cases of biscuit

2181

Excerpt from a list in Scott's diary.
OPPOSITE: Scott writing in his journal in the Cape Evans hut, October 7, 1911.

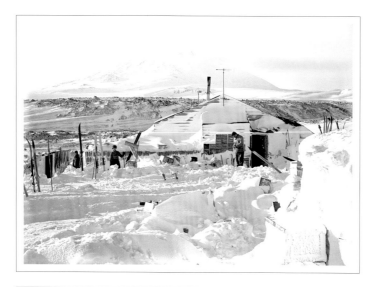

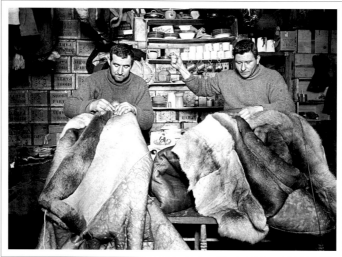

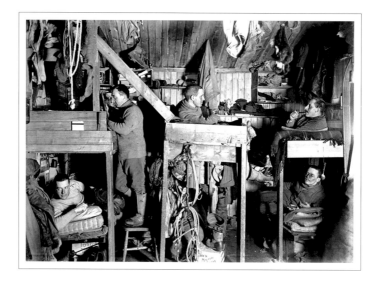

TOP: The first "warm" spring day (-15° F) at Cape Evans hut and Mount Erebus, September 17, 1911.
MIDDLE: Petty Officer Evans and Crean mending sleeping bags. *BOTTOM:* The "Tenements"—bunks in
Cape Evans hut. Lt. Bowers, Mr. Cherry-Garrard, Captain Oates, Mr. Meares, and Dr. Atkinson, October 9, 1911.

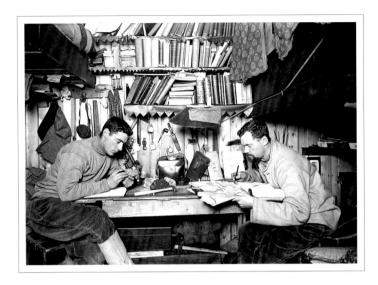

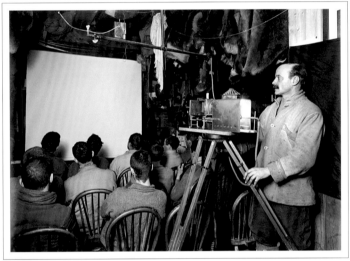

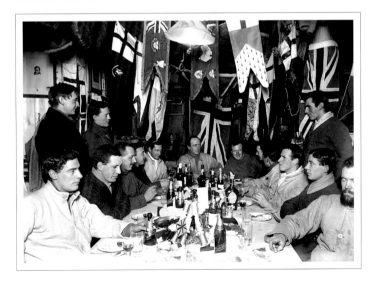

TOP: T. Griffith Taylor and Frank Debenham in their cubicle.
MIDDLE: Herbert Ponting lecturing on Japan, October 16, 1911.
BOTTOM: Midwinter Day dinner in Cape Evans hut, June 22, 1911.

> **"When the sun shone, the sledgers' moods lifted. Cherry-Garrard wrote about the colors and shapes of the snow; the whisper of the sledge."**

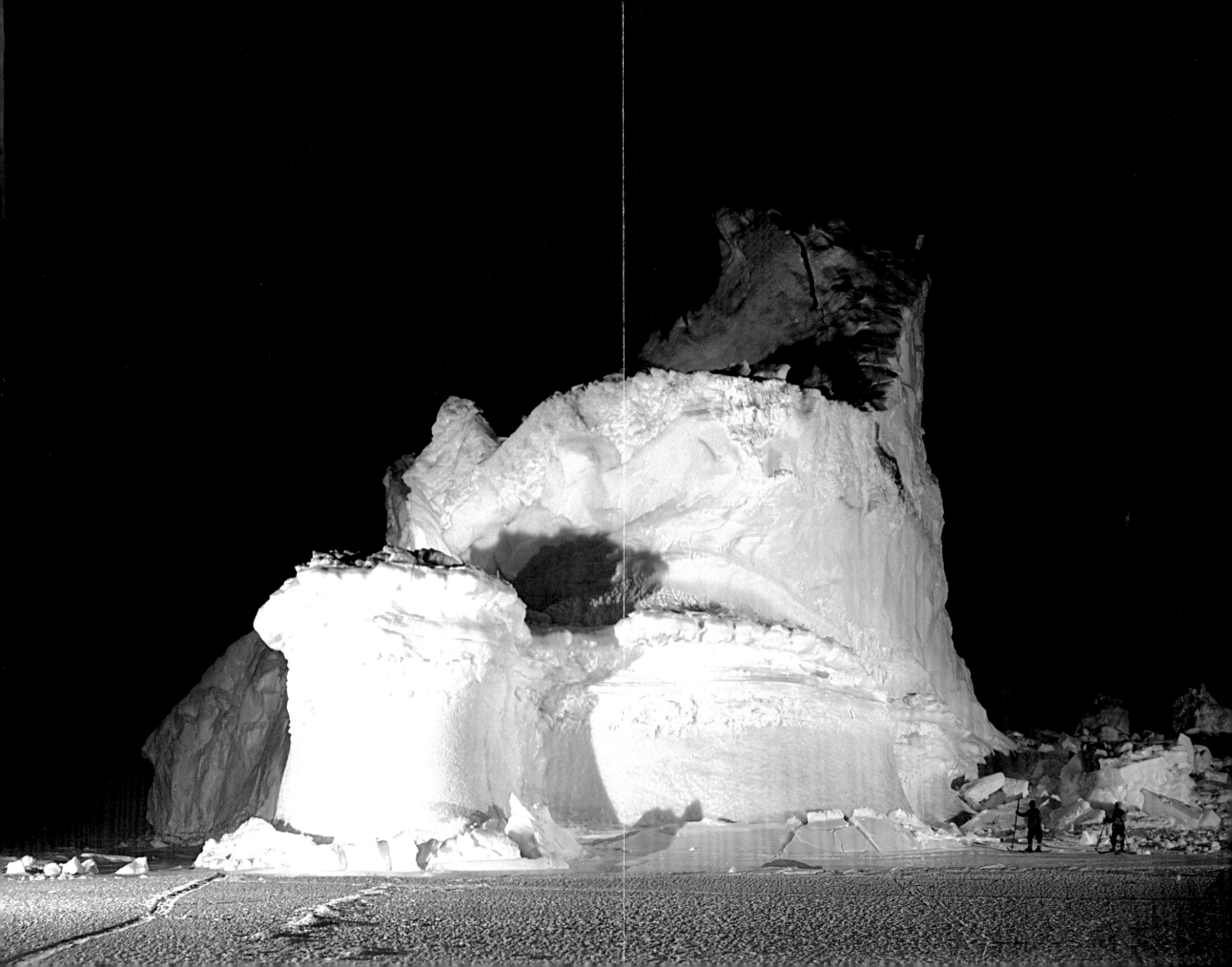

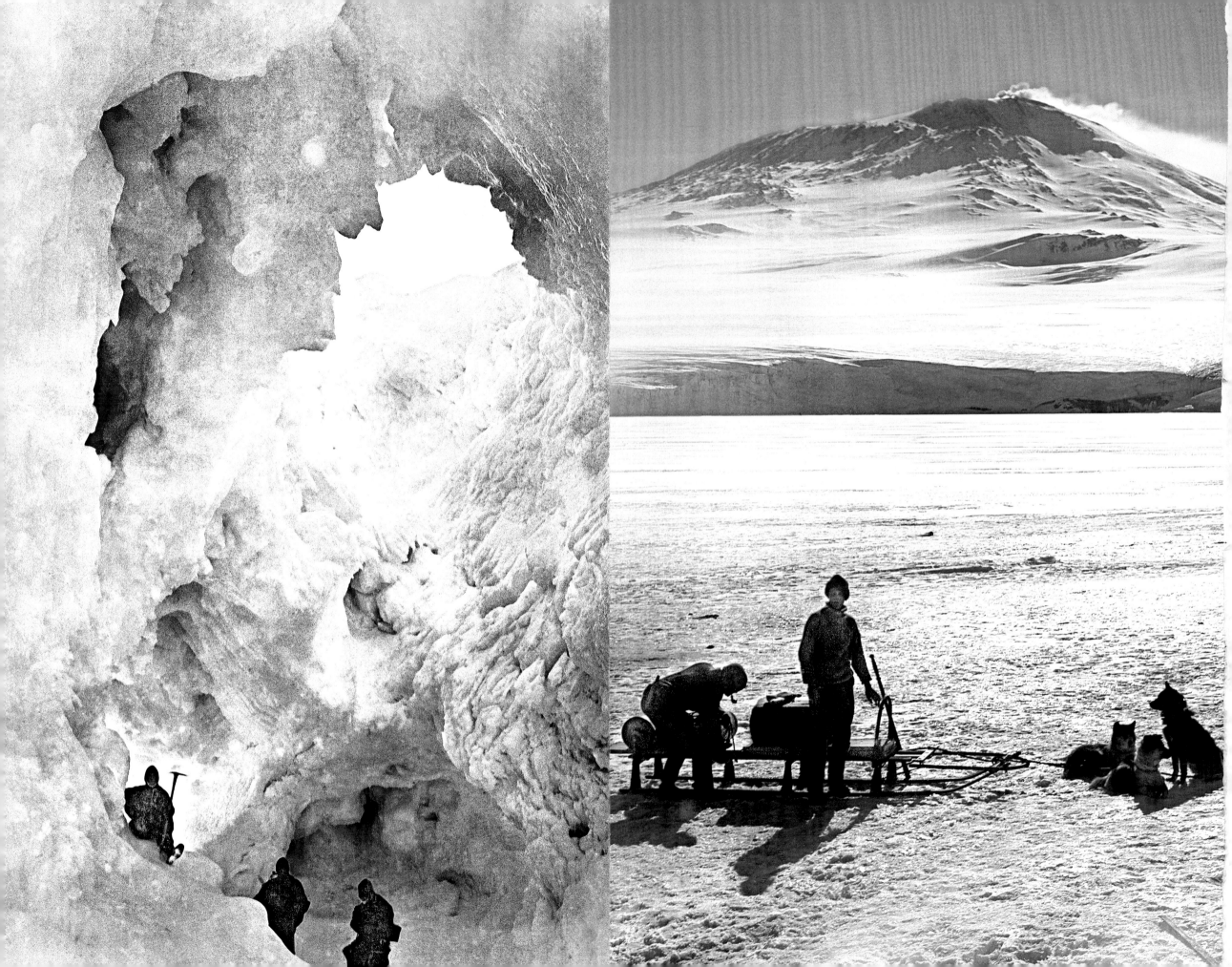

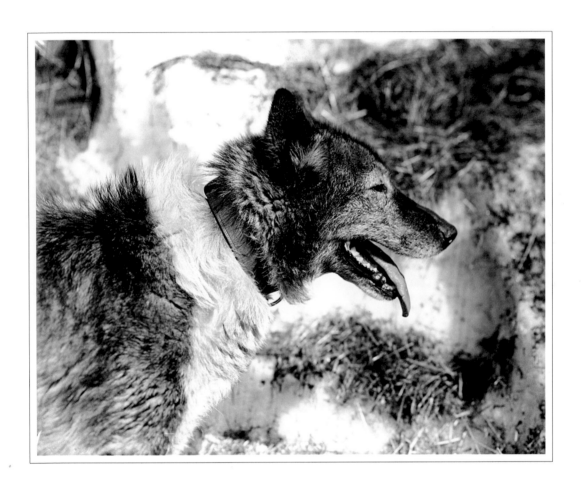

Sledge dog Ostre-nos.
OPPOSITE: Smoke cloud from Mount Erebus.

A line of penguins slides on their bellies across the ice.
OPPOSITE: An expedition member stands on the ice with a mule, near a group of emperor penguins.
FOLLOWING PAGES: Telephoto of the Church Berg, seals, and Western Mountains from Wind Vane Hill.

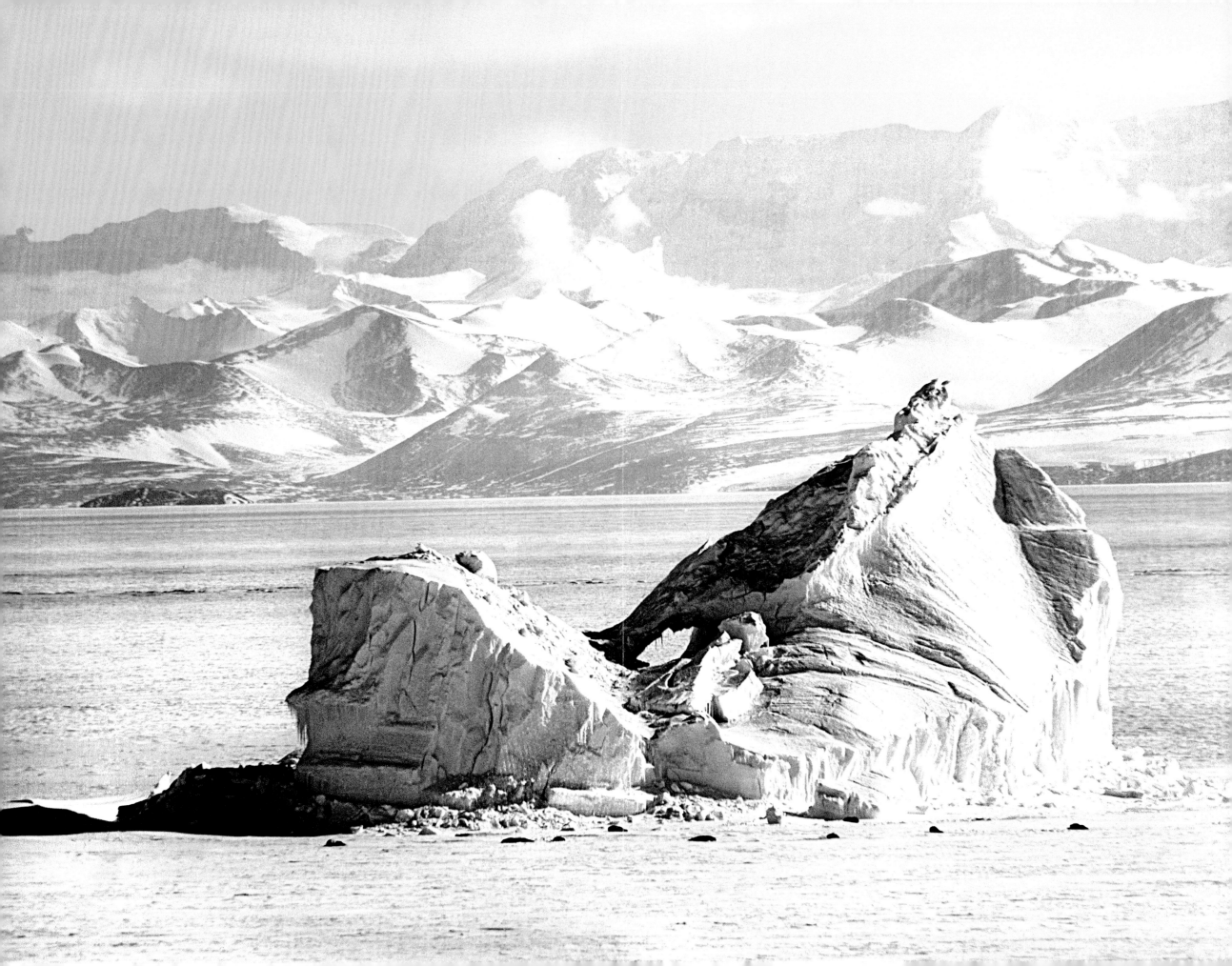

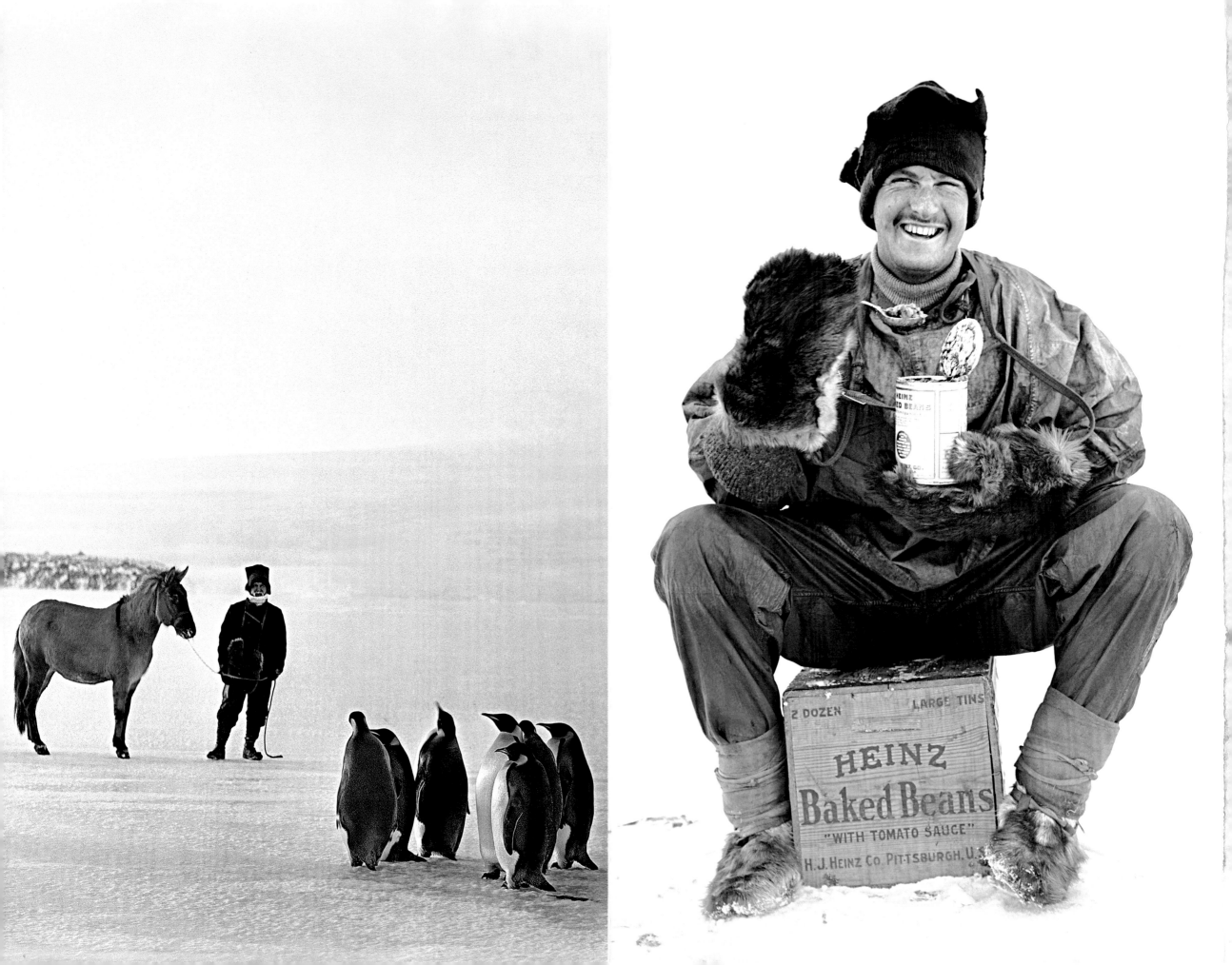

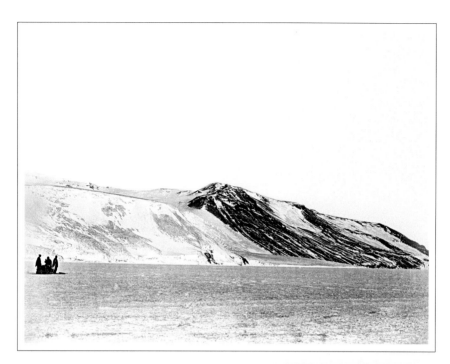

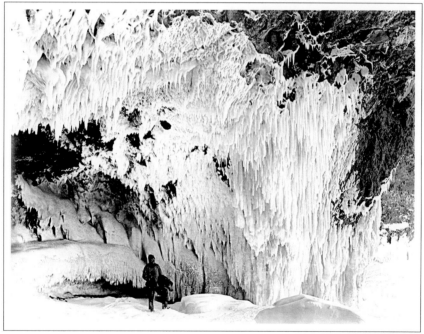

PREVIOUS PAGES (LEFT): In an advertisement for Heinz, one of the sponsors,
an expedition member sits on a box in the snow, enjoying a meal.
(RIGHT): Hooper and Abbot sit inside a tent, next to a camping stove, on rolled-up sleeping bags.
TOP: Three expedition members stand by a laden sledge on a flat snowfield. *BOTTOM:* An expedition member
stands beneath a mass of icicles hanging from the roof of a cave. *OPPOSITE:* Ice cliff.

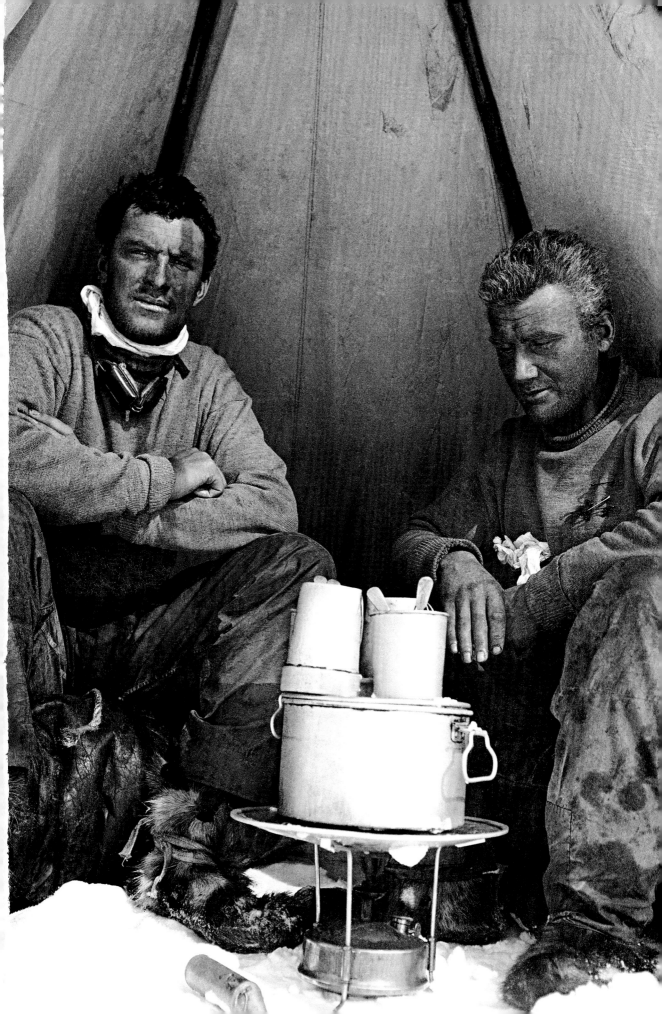

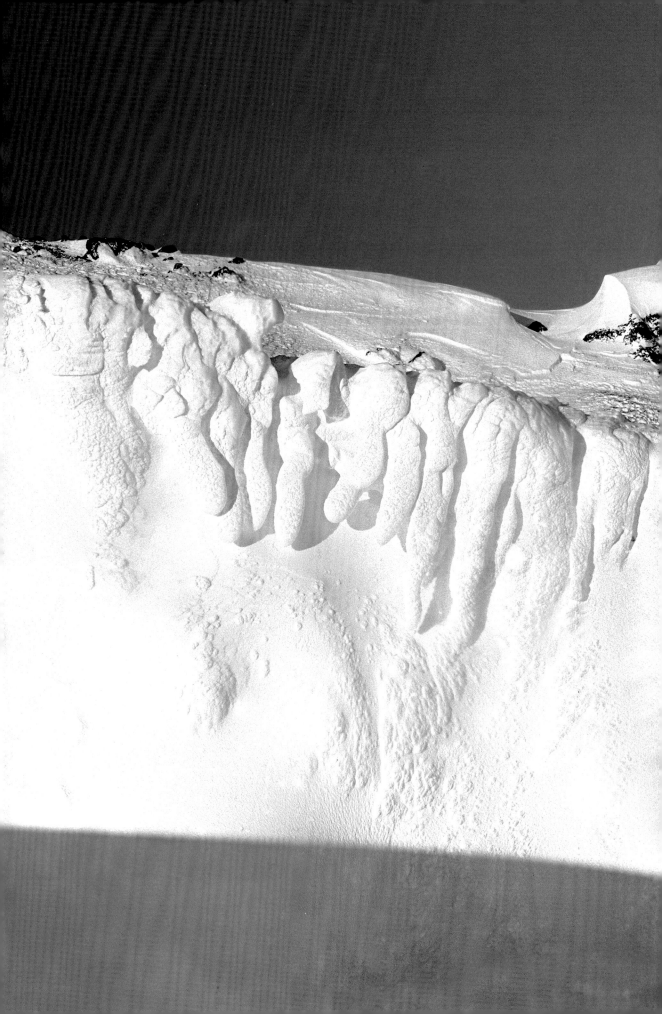

"Bowers tirelessly had worked out the weights of dogs, motors, ponies, and food, calculating the amount of food the men would carry for themselves and the animals in between depots."

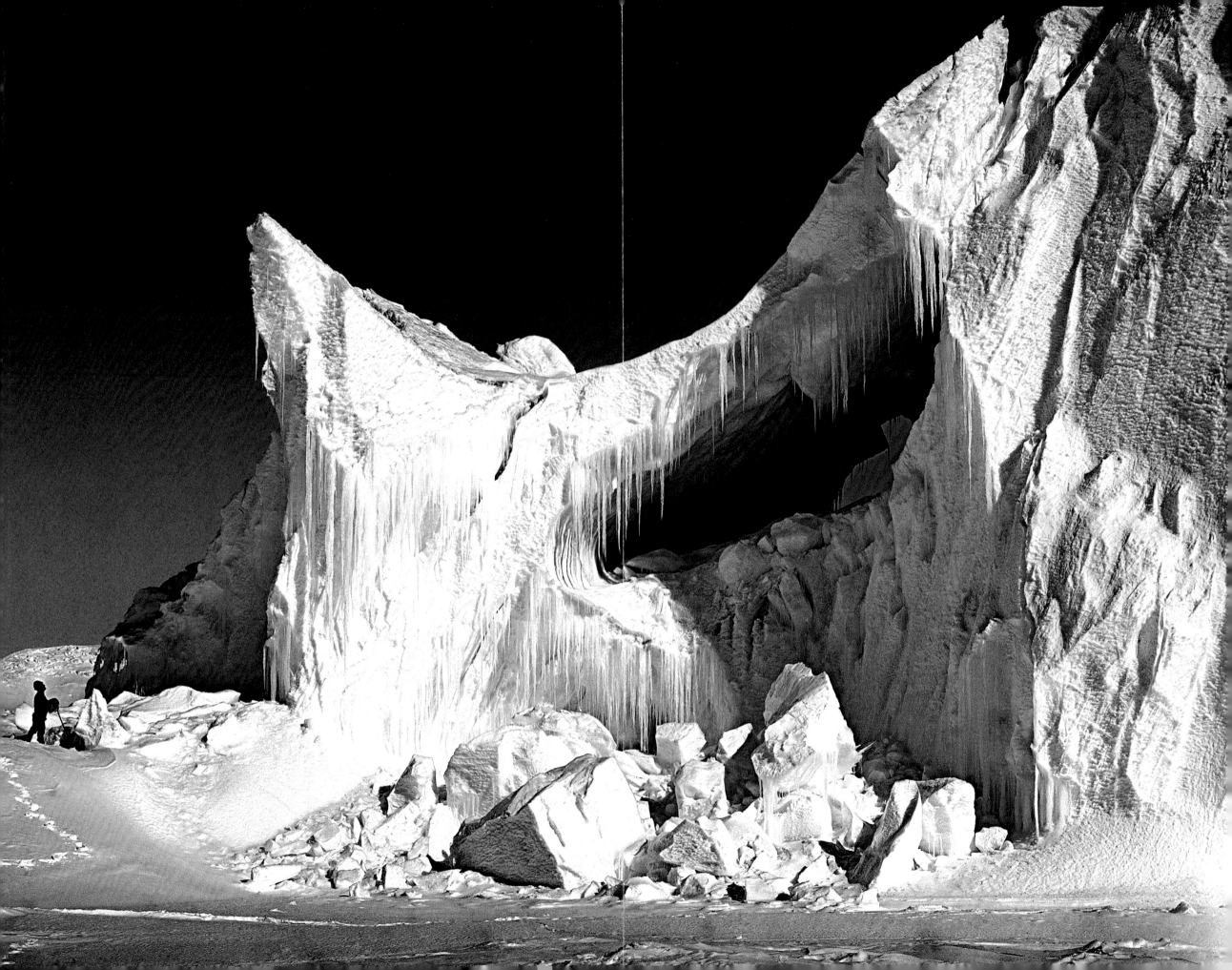

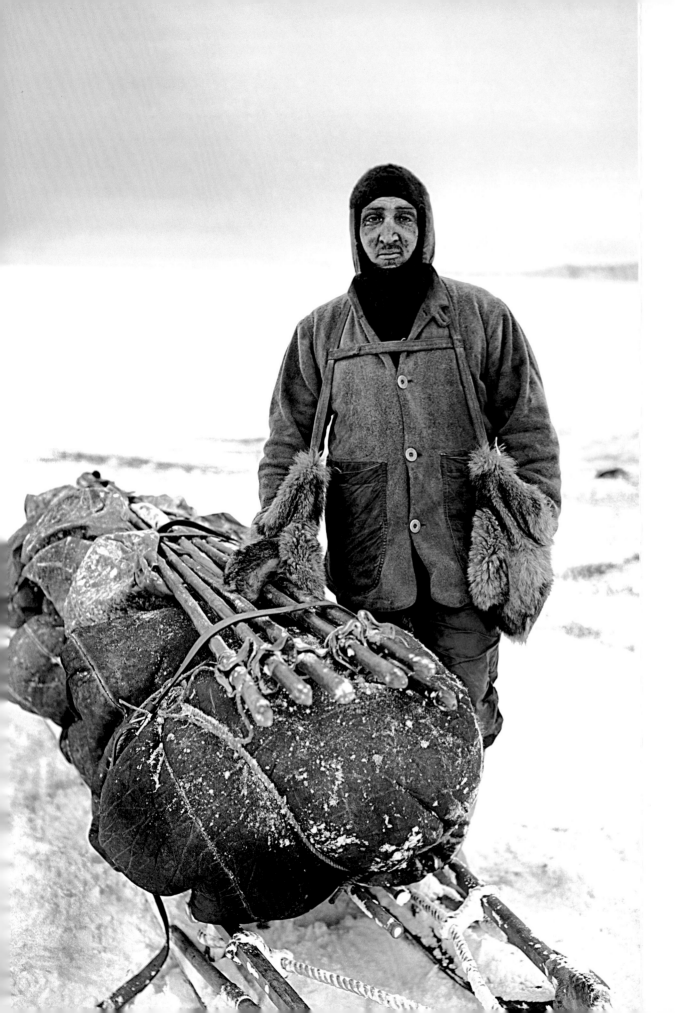

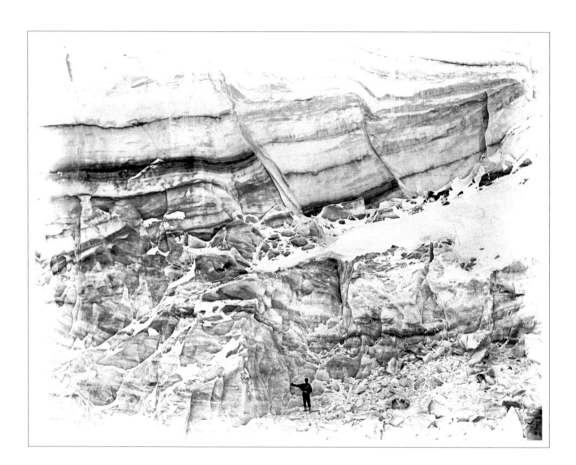

Priestley stands in front of a tall ice cliff.

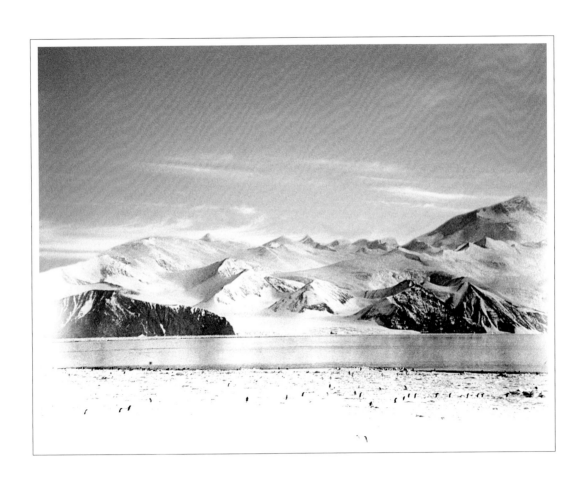

Panorama of the Admiralty range from Cape Adare.

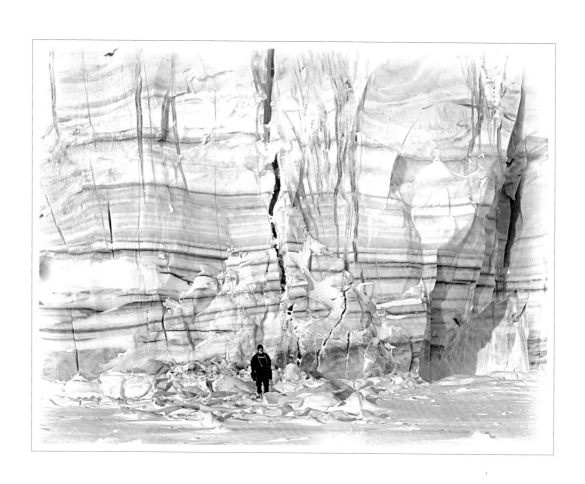

An expedition member stands in front of an ice cliff.

OPPOSITE: View of rocky outcrop of Cape Barne protruding from the ice.

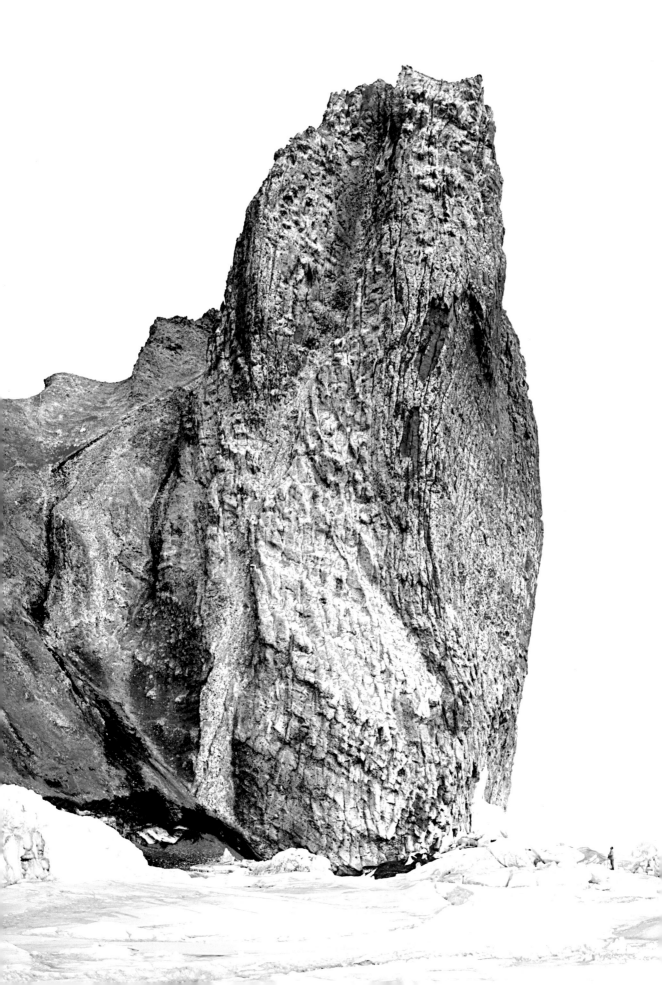

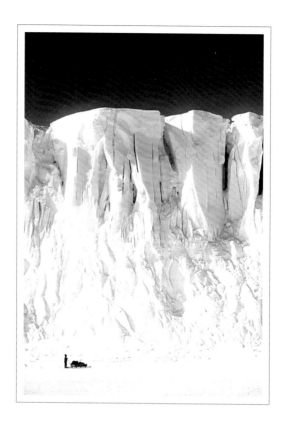

*Impression. – The long mild twilight which like
a silver clasp unites to-day with yesterday; when
morning and evening sit together hand in hand
beneath the starless sky of midnight.*

Anton Omelchenko stands by a loaded sledge at the base of the ice wall of the Barne Glacier, December 2, 1911.
OPPOSITE: An emperor penguin stands on the ice. FOLLOWING PAGES (LEFT): An expedition member stands on a steep rock slope
next to a weathered boulder. (RIGHT): Another member climbs the face of a jagged iceberg, October 8, 1911.

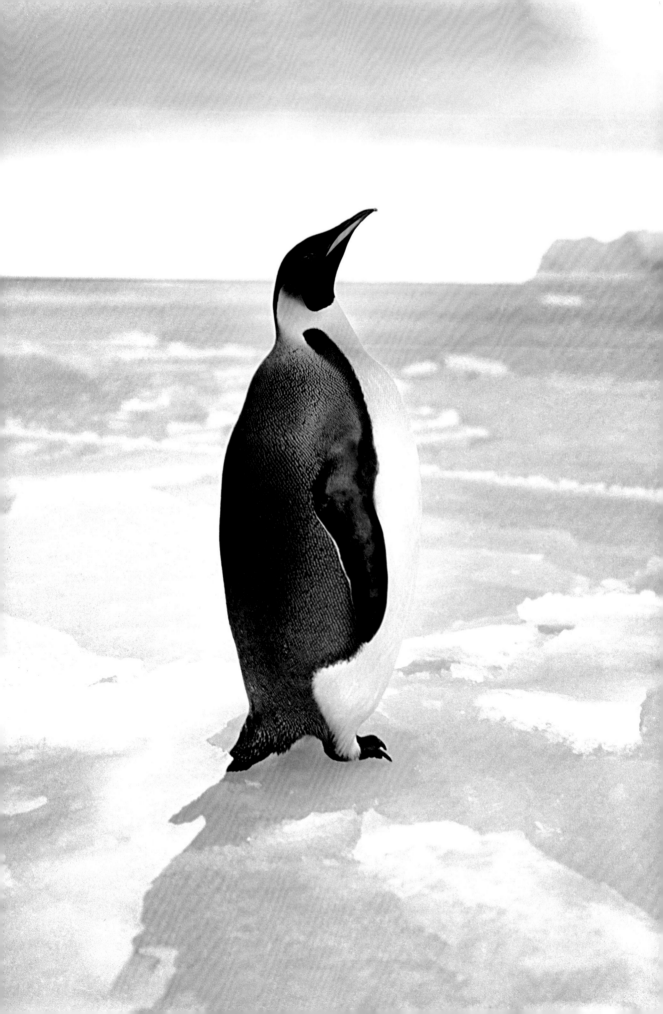

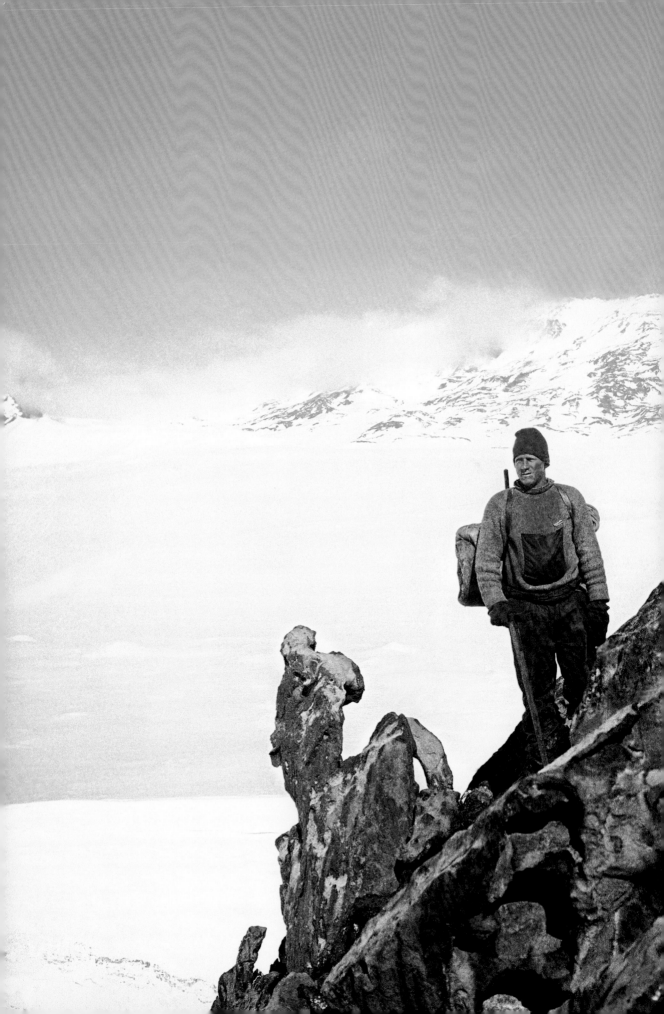

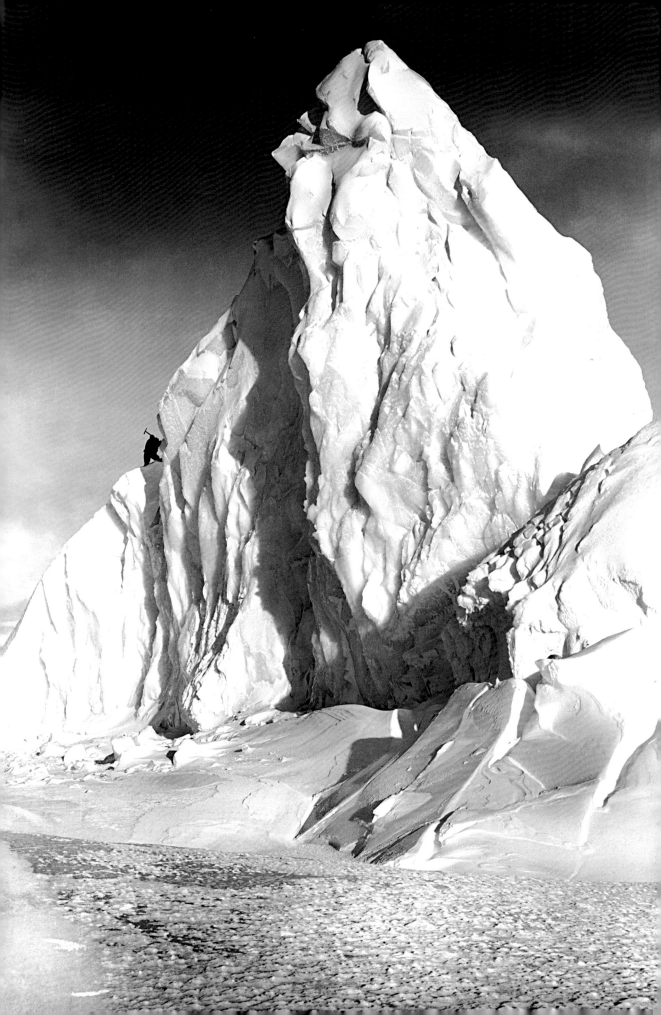

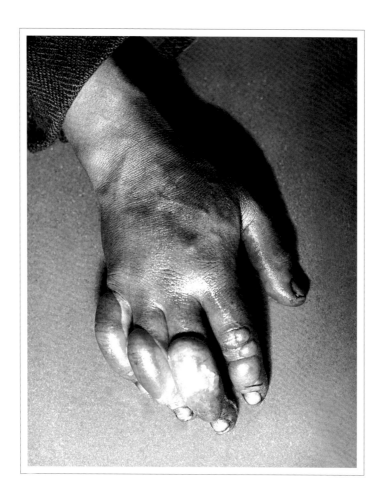

A whole host of minor ills besides snow blindness have come upon us. Sore faces and lips, blistered feet, cuts and abrasions; there are few without some troublesome ailment, but, of course, such things are 'part of the business'.

Dr. Atkinson's frostbitten hand, July 5, 1911. *OPPOSITE:* Mount Erebus and the Barne Glacier. *FOLLOWING PAGES:* Priestley stands in front of an ice cliff.

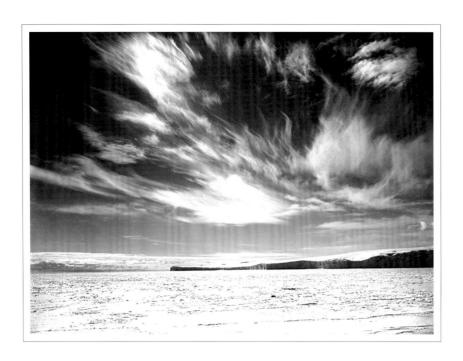

To-night we had a glorious auroral display—
quite the most brilliant I have seen.
 At one time the sky from N.N.W. to S.S.E. as
high as the zenith was massed with arches
 band, and curtains, always in rapid movement.
The waving curtains were especially fascinating—
 a wave of bright light would start at one end
and run along to the other, or a patch of
 brighter light would spread as if to reinforce
 the failing light of the curtain.

Cirrus clouds over the Barne Glacier, December 19, 1911.
OPPOSITE: An expedition member stands by a pyramid tent pitched inside a high cave. Another member stands by a laden sledge.

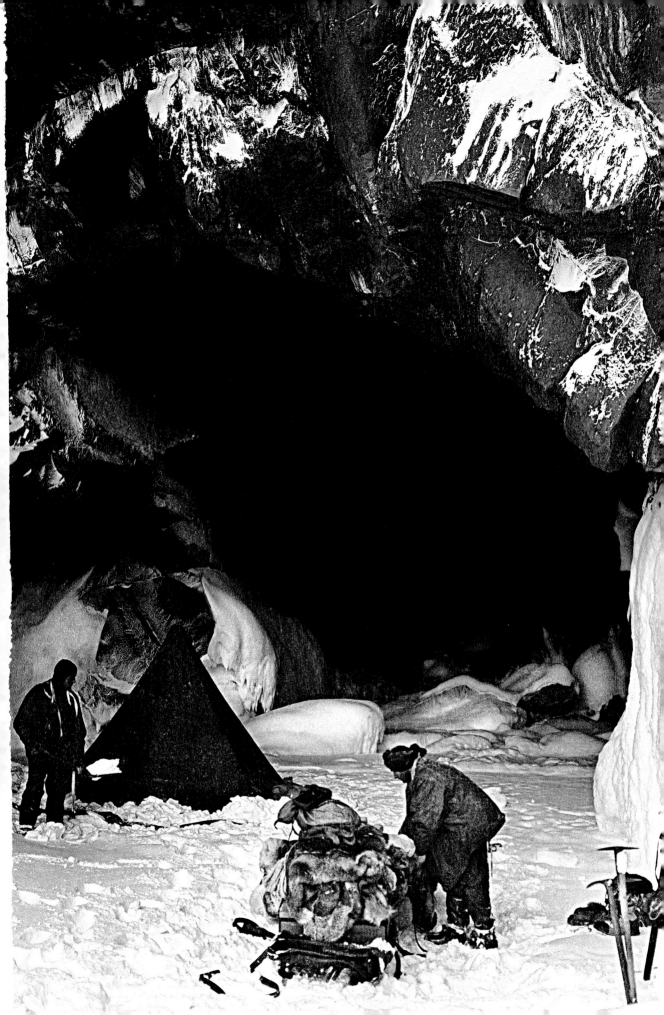

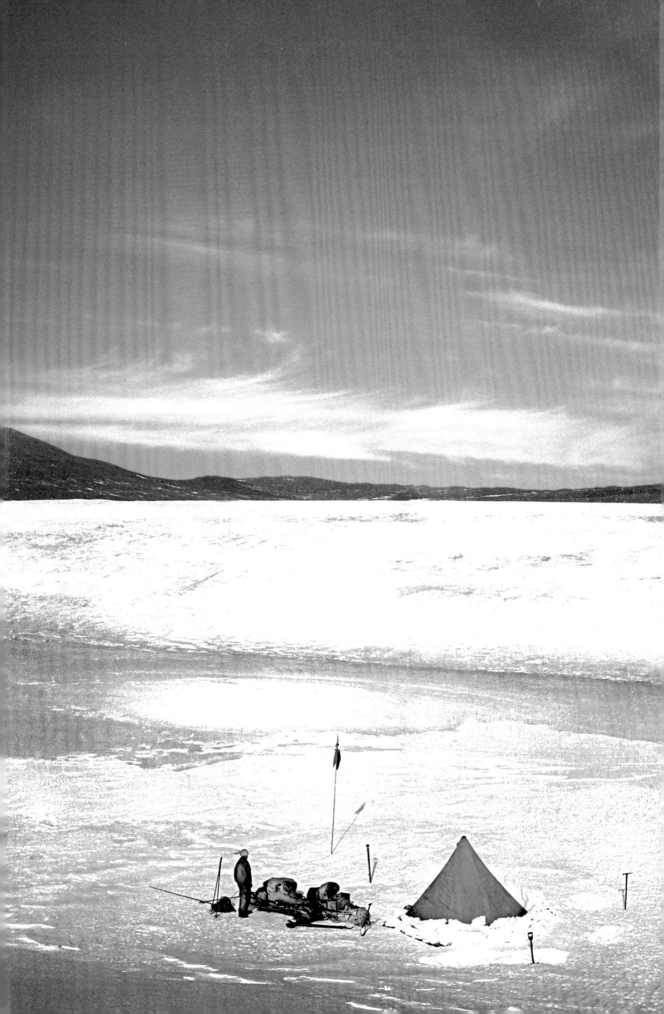

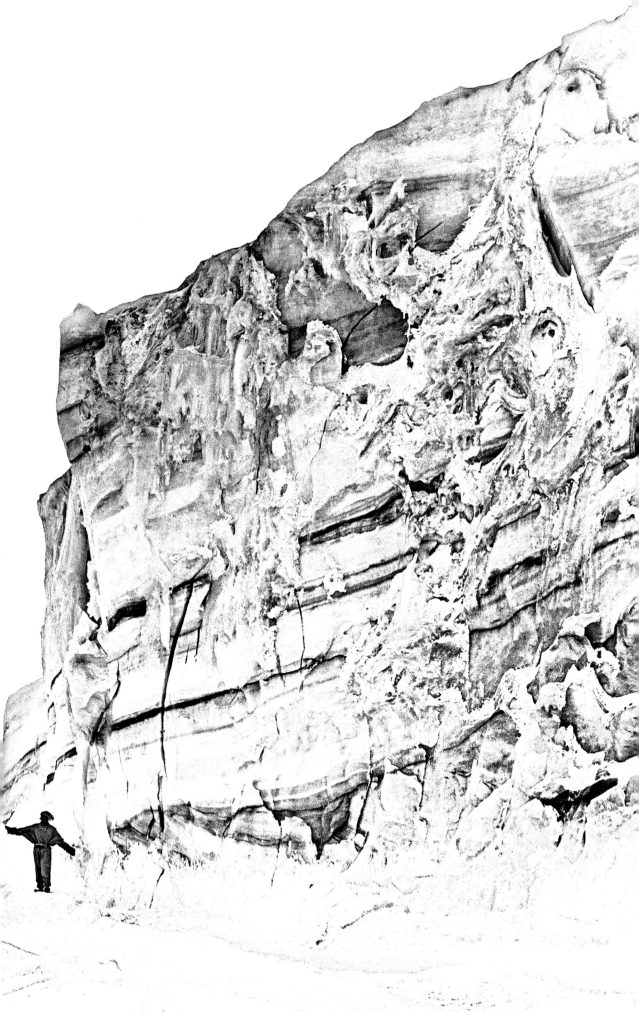

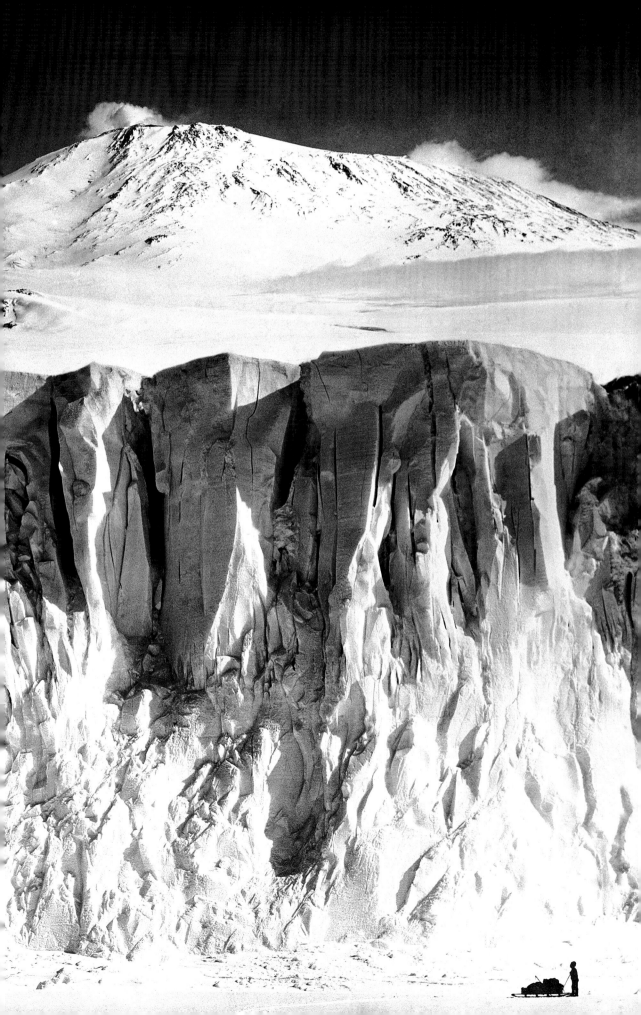

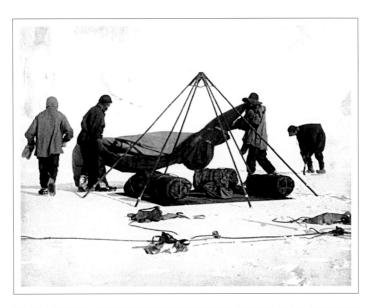

TOP: Four expedition members pitch a pyramid tent on an ice field. *BOTTOM:* Three expedition members roped together on a snowfield, with summit of Mount Erebus wreathed in steam in the background. *OPPOSITE:* An expedition member stands by a laden sledge and a pyramid tent on an ice sheet.

"On January 16, Scott came upon the scene he had long been dreading: a black flag, left by the Norwegians after they reached the South Pole—still some miles away—a month before."

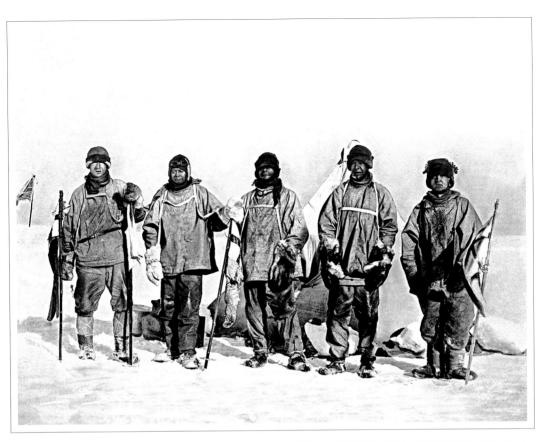

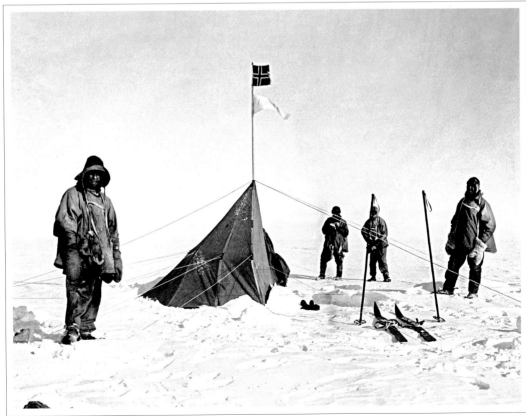

Afterword

The *Terra Nova* expedition left a physical Antarctic legacy: the expedition base at Cape Evans.

The structure sat abandoned until 1947, when crew members aboard the USS *Burton Island* first visited as part of an early contingent to scope McMurdo Sound for what would become in time McMurdo Station. Since the 1950s, New Zealand has taken custodianship of the Ross Island historic huts, including Cape Evans, Shackleton's *Nimrod* expedition base at Cape Royds, and Scott's *Discovery* hut at Hut Point. The first repairs were effected by crew members of Sir Edmund Hillary's Ross Sea Party of the Commonwealth Trans-Antarctic Expedition.

Since 1987, the Antarctic Heritage Trust has restored and maintained the buildings in perpetuity for the benefit of humanity. As a nonprofit organization, the trust aims to both conserve this heritage and inspire people with this remarkable legacy.

By 2000, the trust realized that comprehensive action was needed if the buildings and their contents were to survive for future generations. In 2002 HRH The British Princess Royal, on the centenary of Scott's first arrival in Antarctica, traveled to Antarctica to launch the trust's Ross Sea Heritage Restoration Project. An international team of leading polar and heritage experts produced extensive conservation plans for the buildings and their contents. Funded by the Getty Foundation and the New Zealand government, in consultation with the international community, these conservation plans outline how the conservation work is to be done. Since then, the World Monuments Fund has included the sites on its Watch list of the world's most endangered cultural sites.

Funding from donors around the world has allowed the trust's project to proceed. Managed by dedicated staff, and with a year-round presence in Antarctica, the project has drawn on teams of conservation and heritage experts globally, particularly from North America, Europe, and Australasia. Indeed, in 2006, international teams of conservators began working year-around in Antarctica, a conservation first.

After the restoration of Shackleton's building and the 5,000 items it contains—including the extraordinary discovery of whisky left frozen in time, which sparked international media interest—the focus has now moved to Scott's hut at Cape Evans.

The task is daunting, with several thousand objects in need of conservation and care under difficult conditions. Ice had turned to water and flowed through the building before refreezing, leaving the wardroom table and many other objects stuck in ice. Water had flowed and refrozen under the building, buckling the floor. A wall of snow behind the building was literally burying it, threatening to push the building off its foundations. Massive snow drifts had already collapsed rafters in the stables.

In 2008, the trust began an intensive, six-year conservation program there. Now the hut is structurally sound and weathertight. Work to date includes the installation of weatherproof and waterproof membranes along exterior walls and general repairs to the cladding. Modern windows on the northern and southern sides have been removed and replaced with the original windows. The first phase of long-term snow and ice mitigation measures was successfully completed, with more than 3,500 cubic feet of snow and ice removed from around the building, the stables reinforced, and collapsed rafters replaced. New snow deflectors will minimize snow buildup around the building. In a major undertaking, the internal floor was lifted, more than 70 cubic feet of ice removed, and the subfloor framing strengthened before the floor (including its original linoleum) was relaid, all in its original position. A new roof cladding, as close as possible to the original, also was installed.

Working year-round both at Cape Evans and at New Zealand's dedicated conservation and science facility, Scott Base, teams of conservators have begun the conservation process for more than 8,500 artifacts at Cape Evans. By 2011, over 5,500 artifacts from the *Terra Nova* expedition have been conserved and returned to the site.

To date, almost forty heritage professionals have spent the long dark winters or endless daylight summers on the ice. Their work has been detailed online, with the opportunity for people to interact with the teams in Antarctica and visit the sites virtually via the trust's Web site, www.nzaht.org.

The process of conservation includes carefully sledging objects across the seasonal sea ice to Scott Base, where the artifacts are treated by trust staff over the dark winter months. Meanwhile, over the summer months, the trust's teams deploy to Cape Evans, initially by tracked vehicle across the sea ice and, later in the summer when the sea ice is unstable, by helicopter. The trust's teams of conservators and heritage carpenters spend several consecutive weeks on-site, without even the modern convenience of

showering, working on the collections and building fabric, respectively. They work in a dedicated camp, with a custom-built conservation laboratory and workshop made from converted shipping containers. Long supply chains, a small team of people, demanding and often dirty work, close-quarters living and working conditions, and tenting out for weeks on end in the polar environment have resulted in a challenging but exhilarating mix.

Amazingly, the trust is still revealing new discoveries about Scott's expedition, with teams at Cape Evans poring over historic photographs and piecing the story back together to learn more.

Recently, several famous and high-profile supporters from Britain and elsewhere have spoken publicly on the importance of Scott's legacy and the trust's work. It is not surprising. For not only is Antarctica the only continent where the first human dwellings still stand, but Cape Evans itself is a very powerful and extraordinary place. Under the trust's care, this humble site and Captain Robert Falcon Scott's Antarctic legacy still stand defiant after a century. It remains a touchstone for new generations inspired by the spirit of adventure, exploration, and discovery.

Nigel Watson
Executive Director, Antarctic Heritage Trust

66 *Scott's poignant diary and Ponting's astounding photographs echo down the ages. Remarkably, Scott's last expedition base still stands on the shores of Cape Evans. The Antarctic Heritage Trust is committed to save this site as an inspiration for current and future generations.* **99**

NIGEL WATSON

❝ *Robert F. Scott was a brilliant polar traveler, and the first to arrive at the South Pole by pure man power. This book celebrates the groundbreaking journey of Scott and his team, as they explore one of the world's most stunning— and inhospitable—landscapes.* ❞

SIR RANULPH FIENNES

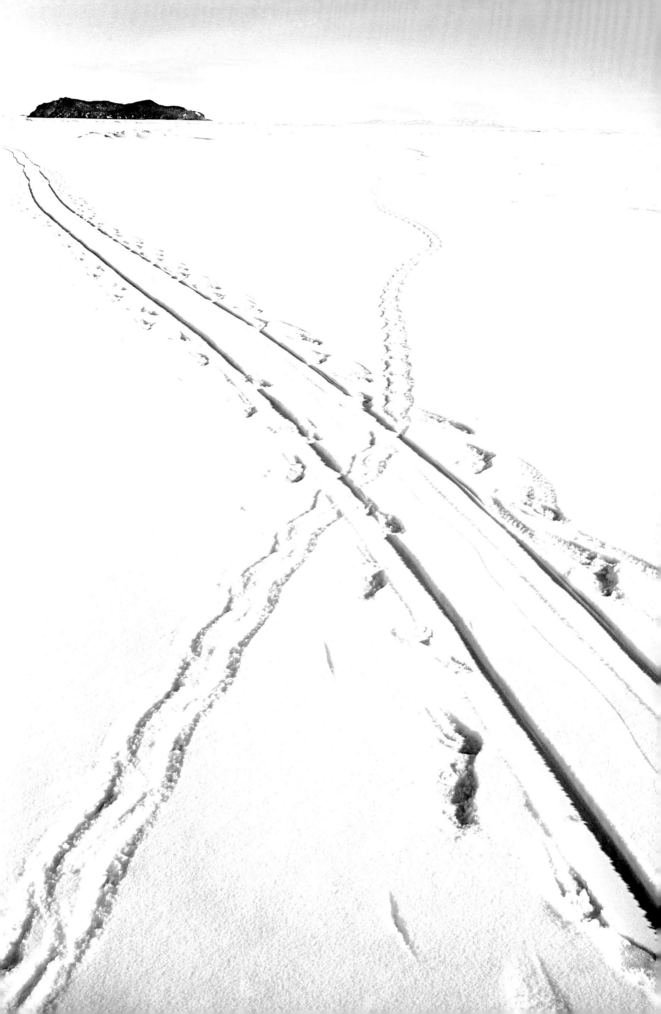

Antarctica is now recognized as one of the world's most important scientific laboratories. Having worked alongside scientists in the region for some years and gained an understanding of the relevance of their quest for new knowledge, I am proud of the Antarctic Heritage Trust's ongoing efforts to save Captain Scott's Antarctic legacy and the very beginnings of scientific discovery in Antarctica.

CHRISTOPHER MACE, CNZM

It's a time warp without parallel. You walk into Scott's hut and you are transported to the year 1912 in a way that is quite impossible anywhere else in the world. Everything is there. There is no dust. Things are nonetheless disintegrating.

SIR DAVID ATTENBOROUGH

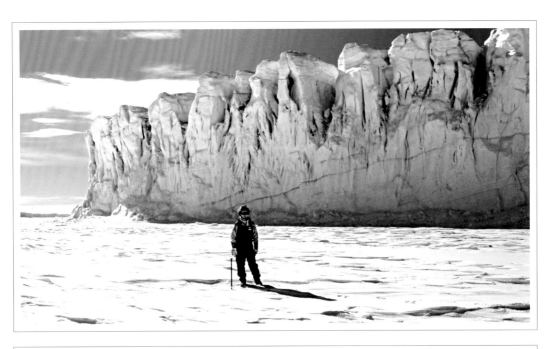

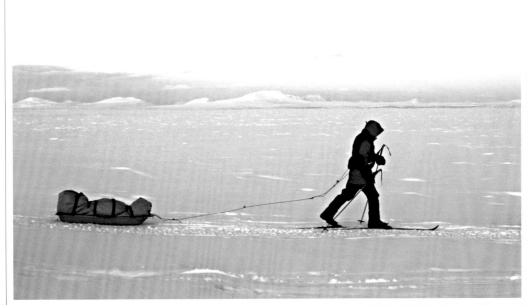

Acknowledgments

The Antarctic is an enigmatic and magical place—one that challenges our spirit and forces us to be strong and resilient in both mind and body. This book has been a mystical journey, filled with the hopes and dreams of many in the past, and it has been my pleasure to produce such a great work that has inspired me to push my thinking past conventional boundaries. I would like to thank Mark Coombs for introducing me to the world of the Pole and for connecting me with the Antarctic Heritage Trust and Nigel Watson, who is a tireless supporter of the Pole. I would especially like to thank my publishers, Prosper and Martine Assouline, and their team, for creating beautiful works of art and for providing a point of view that makes us think differently about ourselves, each other, and the world around us.

Tanja Hall Ellis

For their help in my research, I would like to thank Max Jones and Stephanie Barczewski for their expertise. A hearty thank-you to Nigel Watson, whose keen eye was invaluable in ensuring historical accuracy. A million thanks to editors Ariella Gogol and Amy Slingerland, who made this stunning book a reality.

Christine Dell'Amore

The publisher would like to thank Valerie Jablow, Rory Kotin, Luc Alexis Chasleries at L.A.C. Retouching, Lucy Martin at Scott Polar Research Institute, Falcon Scott and Sophie Gorell-Barnes, Julie Cochrane at National Maritime Museum, and Martin Mintz at the Picture Library of the British Library.